# ART IN THE STATIONS
## THE DETROIT PEOPLE MOVER

This book is provided as a gift

To _____

With the compliments of
The A. Alfred Taubman Foundation.

Irene Walt, Chair
2006

# ART IN THE STATIONS
## THE DETROIT PEOPLE MOVER

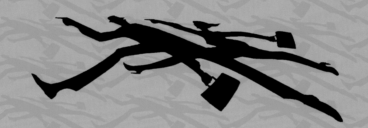

# ART IN THE STATIONS
## THE DETROIT PEOPLE MOVER

The Book Collaborative

Irene Walt, Chair • Dorothy Brodie • Grace Serra
Patrice Merritt • Balthazar Korab • Monica Korab

Photography by Balthazar Korab

Art in the Stations • Detroit • 2004

Copyright ©2004 Art in the Stations

Second Printing 2006

Grateful acknowledgement to the A. ALFRED TAUBMAN FOUNDATION for the provision of a matching grant to reprint *Art in the Stations* in 2006.

Special thanks to Laura Rodwan for her innovative expertise in public relations.

Photographs on pages 13 to 55 ©Balthazar Korab Ltd.

Published by Art in the Stations
26373 Hendrie Boulevard
Huntington Woods, Michigan  48070

ISBN 0-9745392-0-1
Library of Congress Control Number 2003112732

*Book & Cover Design*
Doug Hesseltine, Hesseltine & DeMason Design
Ann Arbor, Michigan

*Writer & Editor*
Christina Bych, aatec publications
Ann Arbor, Michigan 48105

*Production Coordination*
Savitski Design

Manufactured in the United States of America

Printed by University Lithoprinters, Inc., Ann Arbor, Michigan

Front Cover: *In Honor of W. Hawkins Ferry*, Times Square Station, Tom Phardel/Pewabic Pottery
Back Cover: *The Blue Nile*, Broadway Station, Charles McGee

# Contents

# Foreword

Great cities have great dreams, and no city provides greater dreams than Detroit. Facing, as it has, enormous changes of fortune, it has never lost its heart, but has strived forward continuously to inspire hope in its future.

The extraordinary dream that was and is Art in the Stations of the Detroit People Mover provides abundant evidence of the power of community effort. Today this creation stands as a stirring demonstration of what inspired work can contribute to a future still in process.

Many deserve credit for this vision. Mayor Coleman Young persevered in the face of critics. He was ably aided by a dedicated Art Commission and, especially, the unfathomable energy of Irene Walt who, through it all, maintained a belief that it would all come to pass. And indeed it has.

Today the People Mover stations contain a model for the nation of what a public art project can and should be. It is one of the finest art collections on daily view anywhere. The Art in the Stations project, begun in 1984, sets the standard for any and all future efforts. Its thirteen stations present the work of eighteen artists whose tile murals, bronze sculptures, Venetian glass mosaics, and neon installations delight, amuse, provoke, and inspire. It is indeed art for the people. As one travels its path there can be no better statement of how the people themselves have made their city better through faith in what can be and triumphed over what almost was.

— Samuel Sachs II

*Samuel Sachs was director of the The Detroit Institute of Arts from 1985 to 1997. He was director of The Frick Collection in New York from 1997 to 2003.*

# Preface & Acknowledgments

I am proud to have played a role in the Detroit People Mover's Art in the Stations project. To me, it is world-class public art—unique, elegant, and exciting. It is far more than I imagined that it could be.

In the early planning stages of the Detroit People Mover, We saw an opportunity to persuade the various boards and officials to include art as an important feature in each of the stations. While traveling throughout the world, I had come in contact with art in transportation and honestly believed that Detroit deserved this as well.

From the beginning it was an unpopular idea. I was not alone, however. Dorothy Brodie with her indefatigable energy and wisdom, Grace Serra with her tolerance and consummate organizational skills, and James Mitnick, of Turner Construction Company, with his invaluable guidance and counsel were all steadfast colleagues. Together, we were able to gain the tremendous support of Mayor Coleman Young and his administration.

We assembled a volunteer group of civic-minded art lovers. Diverse in their interests and careers, each was enormously committed to the goal of selecting important and beautiful art for the people of Detroit and the State of Michigan. We worked together and we traveled together, meeting artists and visiting other projects. We viewed over 200 artists' slides and vitae. We raised the funds to commission and install the eighteen works of art in the thirteen People Mover Stations. We laughed, we cried, we agreed to disagree, and yet we were able to make compromises. We never forgot our objective— to provide public art that would inspire all people. And we never let go until it was done. This glorious project was completed against all odds.

Its success is due to the wonderful group of enthusiastic and inventive artists who created this elegant collection of public art. They gave their hearts and souls to the project, as did the installers, who, through their consummate skill and devoted effort, made Art in the Stations a reality.

My deep commitment to Art in the Stations occupied four years of my life, day and night. I believed in it, not for glory or money—I did this professional job as a volunteer—but for love of our new home and country. My family made our home in Detroit in 1961, and one of my intentions when embarking on this endeavor was to give to Detroit what Detroit has given to us—something very beautiful.

I could not have completed such a huge task without the love and inspiration of my dear late husband, Alexander. His patient advice and understanding and encouragement stood me in good stead. The love and devotion of my children— John, Steven, and Lindsay—gave me courage and support when I most needed it.

It was our extreme good fortune that Balthazar Korab, photographer extraordinaire, documented this project from beginning to end. Without his magnificent photographs, and the considerable efforts of Monica Korab, this book would not have been possible.

The unending support of Dorothy Brodie and Grace Serra continued throughout the publication of this volume. I am indebted to Patrice Merritt, Executive Director of The Friends of the Detroit Public Library, for her informed input and the countless letters she wrote as scrivener for the project. My warmest thanks to Monica Korab for her invaluable book publishing experience and knowledge which she shared with us. These dedicated women worked with me for nearly three years, reading through the many versions, to achieve this magnificent volume.

I must express my gratitude to the late Grovenor Grimes, "the man on the street," who wrote the original manuscript. Special thanks go to Larry Ebel, for contributing his creative expertise to so many aspects of the Art in the Stations project.

A special mention for Alice Nigoghosian whose encouragement and assistance with final details was very special. I must also acknowledge Savitski Design for their generosity and understanding—without their dedication, this book might not have been completed.

I also wish to acknowledge the wise council of Louis Tertocha and John Walt whose assistance was invaluable to this book.

And lastly my thanks to the generous donors for their faith and generosity towards Art in the Stations.

— Irene Walt, 2004

# Patrons of *Art in the Stations* (2000–2003)

Bank One Foundation

Mr. & Mrs. Mandell L. Berman

Dr. Naomi Breslau & Dr. Glen Davis

City of Detroit Cultural Affairs Department

Cohn Family Foundation

Comerica Bank Fund

Community Foundation of Southeastern Michigan

Compuware Corporation

Daimler Chrysler Corporation Fund

DeRoy Testamentary Foundation

Detroit Newspaper Agency

DTE Energy Foundation

Mrs. Suzy Farbman

Edsel B. Ford II Fund

Ford Motor Company Fund

Mr. Richard Goodman

Mr. & Mrs. Joseph L. Hudson, Jr.

Chaim, Fanny, Louis, Benjamin & Anne Kaufman
Memorial Trust

Dr. Myron & Joyce LaBan

Mr. & Mrs. Robert Larson

Mr. & Mrs. Elmore Leonard

Mr. & Mrs. Daniel Levin

Dr. & Mrs. Frank Lewis

MGM Detroit Grand Casino

Mrs. Helen Mardigian

Dr. & Mrs. H. Michael Marsh

Masco Corporation

Michigan Council for the Arts and Cultural Affairs

Mr. Arnold Mikon, Yamasaki Associates

Plante & Moran

Marianne & Alan Schwartz-Shapero Foundation

Mr. & Mrs. Erwin Simon

Mr. & Mrs. Richard Sloan

Mr. & Mrs. Sam Thomas

Mrs. Alexander Walt

Mr. & Mrs. Ralph Youngren

# Introduction

The art in the stations of the Detroit People Mover is a world-class collection of public art with a uniquely Detroit sensibility. What began as one individual's vision—to have accessible art in each People Mover station—grew into a true community effort. By writing the story of this public art project, this book documents an important event in Detroit's history.

When the People Mover, Detroit's elevated transit system, was being planned, the stations were designed to serve as simple points of entry and departure. Fortunately for the city and its citizens, there were those who saw beyond the utilitarian, who could see the opportunity in bare walls. This determined group decided that if the stations were indeed to become part of the Detroit landscape, they had to be something more than unadorned boxes. The stations had to be vibrant and vital. They had to contain art.

In 1984, Irene Walt, a long-time advocate of art in public places, assembled a committee of eleven fellow Detroiters who shared her commitment to art and public service.

They became the Downtown Detroit People Mover Art Commission, later known as Art in the Stations. This volunteer group immediately undertook its ambitious self-assigned task of incorporating major works by contemporary American artists into the thirteen People Mover stations. In addition to the arduous processes of selecting, commissioning, and shepherding the art works from conception to installation, the Commission also raised $2 million to finance the project. The result of this citizen effort is that Detroit is home to one of the most impressive public art collections in the country.

A goal of the Commission was that the art works reference Detroit whenever possible. The mural in the Financial District station, for example, is titled "D" for Detroit; the Cobo Hall station mosaic depicts seven full-sized automobiles; at the Grand Circus Park stop, a bronze life-sized figure of a man reads the *Detroit News*, a copy of the *Detroit Free Press* folded atop his briefcase. But the Detroit context runs even deeper. Pewabic Pottery, a national treasure founded in Detroit in 1903, created the tile used in five stations, continuing its century-long tradition of adding beauty and artistry

to the city's buildings. Ten of the artists are from Michigan. And, of course, much of the funding was generously provided by local residents, businesses, and organizations.

With lush photographs by Balthazar Korab and accompanying narrative, *Art in the Stations* illustrates and examines each of the glorious works that grace the People Mover stations. In celebrating this art, the book also celebrates the determination, perserverance, and plain hard work of private individuals who take it upon themselves to do something for their city and their fellow citizens. The Art in the Stations of the Detroit People Mover proves that each one of us can make a difference.

As the city of Detroit changes, so does the People Mover transit system. During General Motors' renovation of the Renaissance Center, both the People Mover station and its art were demolished and replaced by a new station and new art—proof of the project's impact and its importance to the people of Detroit. This book documents the art found in the People Mover stations today and serves as a tribute to the original Art in the Stations project.

# The History

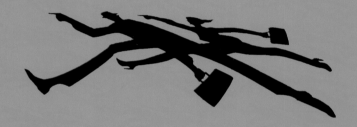

In 1901, a group of civic-minded citizens joined efforts to construct a monument to Madame de la Mothe Cadillac, the wife of Detroit's founder. In addition to honoring their city's past, the members of the Women's Bi-Centenary Committee were determined to create something that "would be a first class credit to the city."

The members conducted Committee affairs in a professional and astute manner. They knew it was important to impress the business community, to whom they looked for financing. They understood the corrosiveness of "popular practical indifference" and worked to derail derision or dismissal of their efforts.

The resulting work—a bas relief tablet depicting Madame Cadillac's arrival in Detroit—was created by a sculptor who had been "chosen in competition with some of the best artists of the country." It was unveiled with considerable pomp in May of 1903 and installed in The Detroit Museum of Art.

The mid-1980s brought an updated version of this story of citizen initiative and service, but one involving a project of vastly greater scope. And just as one's ancestors would hope, the Detroit People Mover Art Commission far exceeded the ambitions of the Bi-Centenary Committee. Art in the Stations is a stellar collection of eighteen magnificent and significant works of art.

An interesting footnote to this story is that the bas-relief of Madame Cadillac is now part of the Art in the Stations collection. When the Detroit Museum of Art was demolished in the 1920s, the bas-relief was salvaged and put into storage in the new museum, The Detroit Institute of Arts. It remained there, out of public view, for sixty years—until the Detroit People Mover Art Commission requested a permanent loan of the bronze tablet for installation at Cadillac Center Station.

## Detroit Deserves No Less

In 1983, construction of the Detroit People Mover, a 2.9-mile elevated transit system, was just beginning in the city's downtown. When Irene Walt saw a newspaper photo of the pylons being set, she sensed an opportunity to do something important for her adopted home. Upon investigation, she discovered that the thirteen People Mover stations were to be basic, unembellished, strictly functional structures. A long-time advocate of public art and a prime force in beautifying the commons of Detroit, she determined that the stations had to be more than impersonal boxes with turnstiles. Thinking of the "exuberant" and "spectacular" stations of London's Underground, and the legendary chandeliered and art-filled metro stations of Moscow, she believed that Detroit deserved no less.

However, her idea was met with little enthusiasm when she approached those responsible for the transit system's development. Then, in the summer of 1984, she met David McDonald, the People Mover's project director. Whether it was her infectious enthusiasm, or her reputation for successful arts projects, or because his son was an art major, McDonald was taken with her vision.

When McDonald brought the idea of art in the stations to the Board of the Southeastern Michigan Transportation Authority (SEMTA), the agency then responsible for the People Mover, its response was positive as well. SEMTA provided seed money, office space, and an intern, Cheryl Wragg, to the fledgling arts project. In September 1984, the Detroit People Mover Art Commission—later known as Art in the Stations—was established as an independent nonprofit entity under the aegis of SEMTA. Mayor Coleman A. Young, aware of Irene Walt's commitment to beautifying the city, her extensive experience as art director of Detroit Receiving Hospital, and her record of successfully completed art projects, asked her to chair the Commission.

While SEMTA oversaw the initial stages of the rail system's construction, ownership of the People Mover transferred to the Detroit Transportation Corporation (DTC) in October 1985. The DTC completed the system's construction in July 1987, and continues to operate it today. Both agencies were instrumental to the success of Art in the Stations, but it was Mayor Young and Dorothy Brodie, then the Executive Assistant to the Mayor and Chair of the DTC, who became ardent activists for the group and its staunch champions. Without their advocacy of Art in the Stations, the project would never have succeeded.

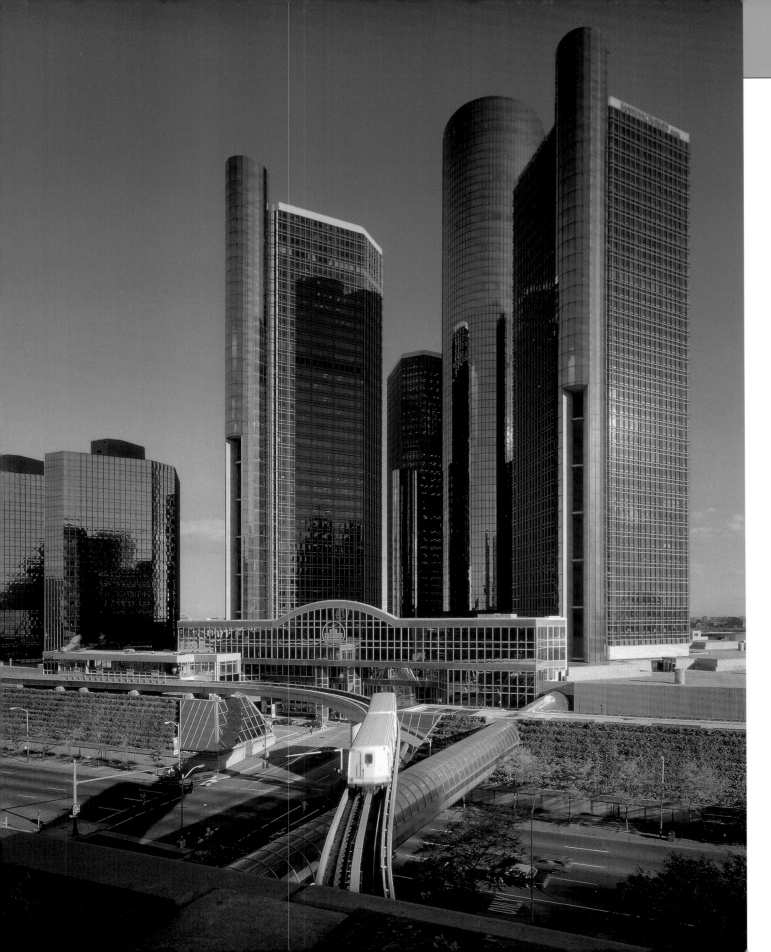

## The Commission

The goals of the all-volunteer Detroit People Mover Art Commission were to select the artists who would create the art for the thirteen stations, raise the funds to pay for the art and its installation, and take the project to completion.

Irene Walt's immediate task, however, was to fill the Commission's twelve seats. From her years of community involvement, she knew that membership mix was crucial to a committee's success. Some of those invited to join the Commission were knowledgeable in the arts and engaged in the arts community; others possessed crucial, though not necessarily art-based, skills. Diverse in many ways, with individual perspectives that guaranteed stimulating discussion, the group was unified by each member's desire to make a significant contribution to the city.

In the mid-1980s, the concept of public art in transit systems was relatively new to the United States. There was only one similar project underway at the time—in Buffalo, New York. The art advisor to the Buffalo Transit System, Nina Freudenheim, agreed to give the Art Commission an in-depth tour of the project, and she freely shared her expertise and hard-won knowledge. The trip to Buffalo provided the Commission with invaluable real-life experience. Seeing the work in progress, and learning firsthand of possible pitfalls, saved them from untold disasters. One of the first things the Commission discovered was that the art they had envisioned for the Detroit stations was much too small in scale.

3

The spectacular large works that were being installed in Buffalo, especially those by Joyce Kozloff and George Woodman, convinced them of that. Both artists would later create works for Detroit's transit system.

In October 1984, the artist selection process began.

## Artist Selection

The objective of Art in the Stations was to provide art for the people.

The Commission's number one prerequisite for the works was artistic excellence, but the trip to Buffalo had taught them that practical considerations could not be neglected. The magnificence of the art would hardly matter if it could not withstand the rigors of constant public exposure, the possibilities of vandalism, and the cold realities of a Michigan winter. Durability and ease of maintenance had to be factored into the decision-making. This eliminated certain materials, but a range of media are represented nonetheless. Of the eighteen works, two are constructed of Venetian glass mosaic; two are enamel paint; four are bronze; one is neon; and nine are tile.

Although certain media were cut from consideration, the artists who work in those media were not. Although paint on canvas did not meet the durability requirements, two painters —Alvin Loving, Jr., and Allie McGhee—received Michigan Council for the Arts grants to study at Pewabic Pottery where they learned to translate their art to ceramic tile.

> The intention was not to create an art museum, but to place art that . . . would become part of our daily lives and that would color our world as a better place to live.
>
> —Irene Walt

It was also important to the Commission that the artists and their work represent the diversity of the Detroit region. Local and national artists, male and female, of diverse heritage received commissions.

Criteria established, the Commission approached the artist community. With the assistance of local arts groups, a list of 200 visual artists from throughout the nation was assembled. The artists were sent letters that detailed the Art in the Stations project, and which invited them to submit slides and background information for the Commission's consideration.

By May 1985, after viewing hundreds of slides, the Commission had narrowed its prospect list. A number of artists were invited to Detroit to meet with the members and to visit the sites to select a station. Back in their studios, the artists were to prepare proposals and produce preliminary drawings.

After reviewing these submissions, the Commission held a blind vote to determine which artists would advance to the next step, which was to create a maquette—a miniature of the proposed work. Art works in their own right, the maquettes are on display in the Control Center of the People Mover transit system at Times Square Station.

Fifteen artists were awarded commissions in 1985. In addition to creating their art, the artists now began to work closely with the People Mover's architects and engineers to ensure that any design and structural modifications necessary to accommodate their art works would be made. The selection process concluded in 1991 with the addition of three final commissions. Grace Serra was recruited as executive director to be responsible for grant writing, planning, and financing.

## Community Contributions

Fundraising was an all-out, ongoing effort that ran the life of the project. Even as art and artists were being selected, the Commission was searching for the money to pay for what promised to be a very expensive endeavor.

In addition to providing a tangible representation of the yet-to-be created art, the artists' maquettes proved to be invaluable marketing tools. Miniaturized reproductions of the maquettes were installed in scale models of the stations, creating a dazzling, tantalizing, reality-based vision of what could be in downtown Detroit.

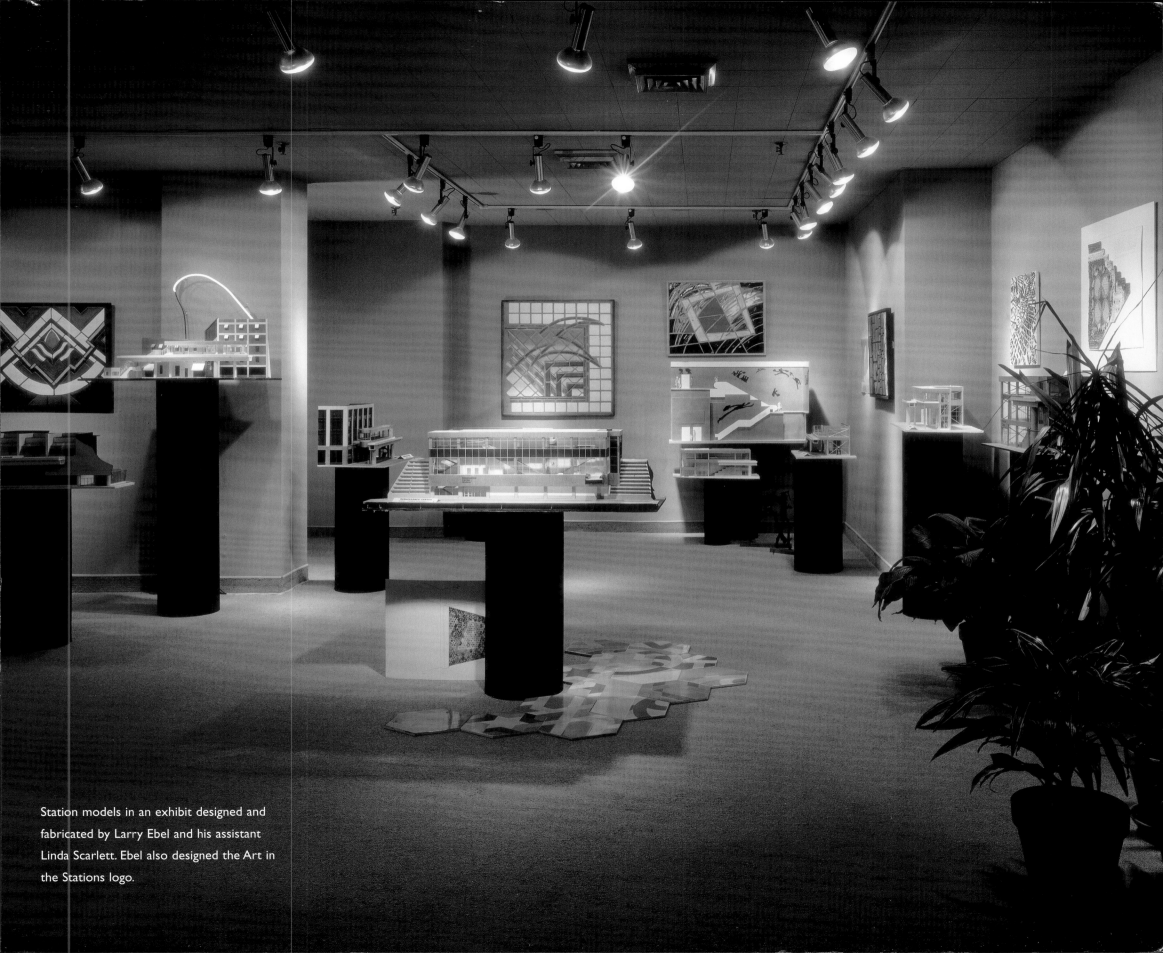

Station models in an exhibit designed and
fabricated by Larry Ebel and his assistant
Linda Scarlett. Ebel also designed the Art in
the Stations logo.

The Commission was given office space within the DTC office complex, as well as gallery space to display the maquettes. To broaden support for the project and to enhance fundraising efforts, Mayor Young had the collection of maquettes moved to his conference room in City Hall. He then invited the Detroit City Council to a private viewing—and thereby secured their support for the project. He also arranged for the Art Commission to present the maquettes at a meeting of the Detroit Renaissance Board, a group of local corporate leaders. The support of this distinguished organization was very important to the overall fundraising effort.

Following its successes at the Mayor's office, the collection returned to the DTC gallery, which, in the meantime, had been turned into a sophisticated showcase by Larry Ebel and a volunteer staff using donated materials. This venue was also a major asset to fundraising. The Commission would invite individuals and groups—representatives of corporations, foundations, and businesses; members of the financial, educational, and cultural communities; philanthropists; the media; and others—to the gallery. There, potential donors of funds and energy could view the impressive display of thirteen three-dimensional miniature stations, with full-color, to-scale works of art in place, and see for themselves the quality and magnitude of Art in the Stations. It was undeniable: The People Mover stations, already under construction throughout the downtown, would be beautiful, vital, and positive additions to the city.

> You can't sell an idea. You must have a product. We had the artists make these wonderful maquettes, so people could see what they were getting for their money.
>
> —Irene Walt

Commission members enlisted friends, colleagues, and family to the cause. Armed with scripts and slide shows, they would make presentations to groups and organizations all over the area. Hundreds of letters were written, a staggering number of phone calls made. Ultimately, the $2,000,000 needed to finance Art in the Stations was obtained.

Just as the Woman's Bi-Centenary Committee had to combat "popular practical indifference" in 1901, the Detroit People Mover Art Commission faced an uphill battle. The result of a well-intentioned federal attempt to revitalize the downtowns of the nation's big cities, the People Mover transit system was not embraced by the people of Detroit.

Although the efforts of the citizen Art Commission were lauded and appreciated, initially they generated little true enthusiasm. Many expressed doubt—both publicly and privately—that such an ambitious project could be successfully completed. Both the downtown transit system and its art collection were viewed by some as little more than the pipe dreams of a city in decline.

But the naysayers could not have been more wrong. On July 28, 1987—just three years after Irene Walt approached SEMTA with her idea—over 700 Detroiters attended a black-tie gala hosted by Mayor Coleman Young. They were celebrating the opening night of Art in the Stations and the Detroit People Mover.

One Detroit Center

In one stroke, Detroit now has one of the most impressive collections of public art work in the country. In itself, it should become one of the city's major tourist attractions. Frankly, if this doesn't make you feel good about your city, I don't know what will.

— George Cantor,
*Detroit News,* 29 July 1987

## Pewabic Pottery

Art in the Stations presents a fascinating maze of Detroit interconnections. The bas relief of Madame Cadillac's arrival, installed in Cadillac Center Station, was a gift from the city's past. *Cavalcade of Cars*, the mosaic mural in Cobo Center Station, is a homage to the local industries. Joyce Kozloff's hand-painted ceramic mural in the Financial District Station was inspired in part by James McNeill Whistler's Peacock Room, which industrialist Charles Lang Freer had moved from England to his Detroit home in 1904. (It is now housed in the Freer Gallery of the Smithsonian Institution in Washington, D.C.) Mr. Freer was a patron of Mary Chase Perry Stratton, who founded Detroit's famed Pewabic Pottery, which became an integral part of Art in the Stations. The Pottery produced the tile for four People Mover stations and created the art works for three.

Mary Chase Stratton started Pewabic Pottery in 1903 as Detroit's manifestation of the international arts and crafts movement, which had begun in England a few years earlier. The movement advocated a return to hand-crafted decorative arts—a response to the rise of industrialization that Detroit would soon symbolize.

Pewabic's contribution to arts and crafts was beautiful handmade architectural tiles with their signature iridescent glazes. Pewabic Pottery attained national stature, and its tiles have been installed in buildings throughout the country. Among these buildings are the National Shrine of the Immaculate Conception in Washington, D.C.; the Nebraska State Capitol; the Herald Square Metro Station in New York; Rice University in Houston; and numerous Detroit landmarks—the Guardian and Fisher buildings; Christ Church Cranbrook; the Detroit Public Library; the Detroit Medical Center; and Comerica Park. They have also been installed in many private homes in the Detroit area. The Pewabic Pottery building on Jefferson Avenue, near the riverfront, is a National Historic Landmark.

Yet another Detroit institution played a significant role in Art in the Stations. In the 1930s, Detroit's famed Stroh Brewery commissioned Pewabic to produce thousands of tiles for an intended expansion of its facilities. The addition was never built, however, and the tiles were put into storage. Many years later, when Peter Stroh learned of Art in the Stations, he offered the tiles to the committee, if they thought there might be a use for them. There was. The magnificent, multiple arches of the Cadillac Center Station (see opposite page) were built of 26,000 green tiles from the Stroh donation. The tiles were also used to create the luminescent backdrop for Marshall Fredericks' *Siberian Ram* at the Renaissance Center Station. The *Siberian Ram* was re-installed at the new station in 2004.

Pewabic Pottery's involvement with the People Mover art project was beneficial on several levels. While it provided a strong Detroit subtext to the collection, the commissions the Pottery received from Art in the Stations saved it from closing. "If the People Mover commissions go through," Mary Jane Hock, then executive director of the Pottery, said in October 1985, "it would mean that Pewabic becomes a working art pottery

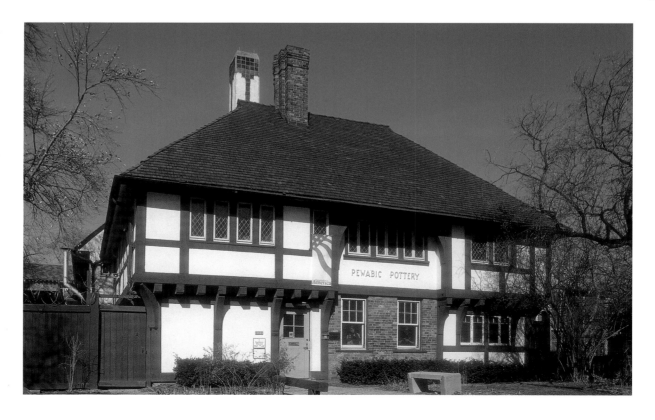

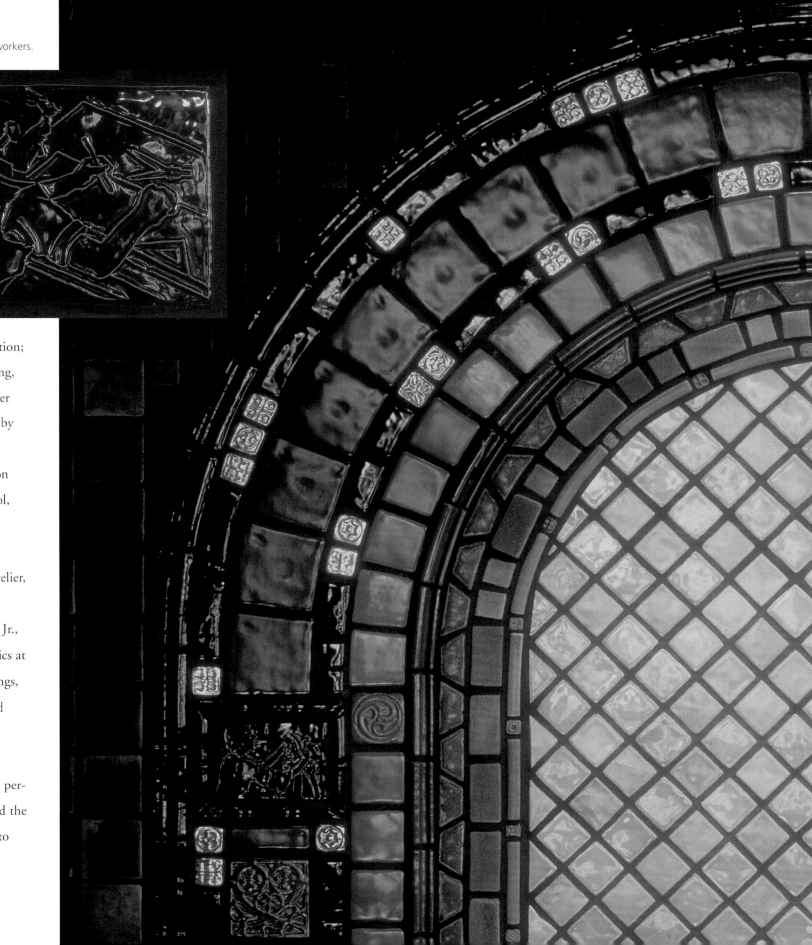

again. . . . It would be the best thing that could happen to us."

The murals in four stations are made of Pewabic tile: Pewabic Pottery's *In Honor of W. Hawkins Ferry* by Tom Phardel and the signature mural for Art in the Stations by Anat Shiftan, both in the Times Square Station; Allie McGhee's *Voyage* at Michigan Avenue; Alvin Loving, Jr.'s, double mural *Detroit New Morning* at the Millender Center; and Pewabic's *In Honor of Mary Chase Stratton* by Diana Pancioli at Cadillac Center. Pancioli integrated Pewabic's "Detroiters at Work" tile series, which Stratton had created in 1926 for Detroit's Northern High School, into the design of that station.

Mary Chase Stratton wanted Pewabic to become "an atelier, a place where many artists work together." Art in the Stations realized this concept when painters Al Loving, Jr., and Allie McGhee were awarded grants to study ceramics at the Pottery. This enabled them to translate their paintings, which otherwise would not have met the durability and maintenance criteria for public art, into tile.

*American Craft* magazine declared Pewabic Pottery "the perfect partner" for Art in the Stations. This union fulfilled the arts and crafts ideal of combining utility and beauty into objects of everyday life.

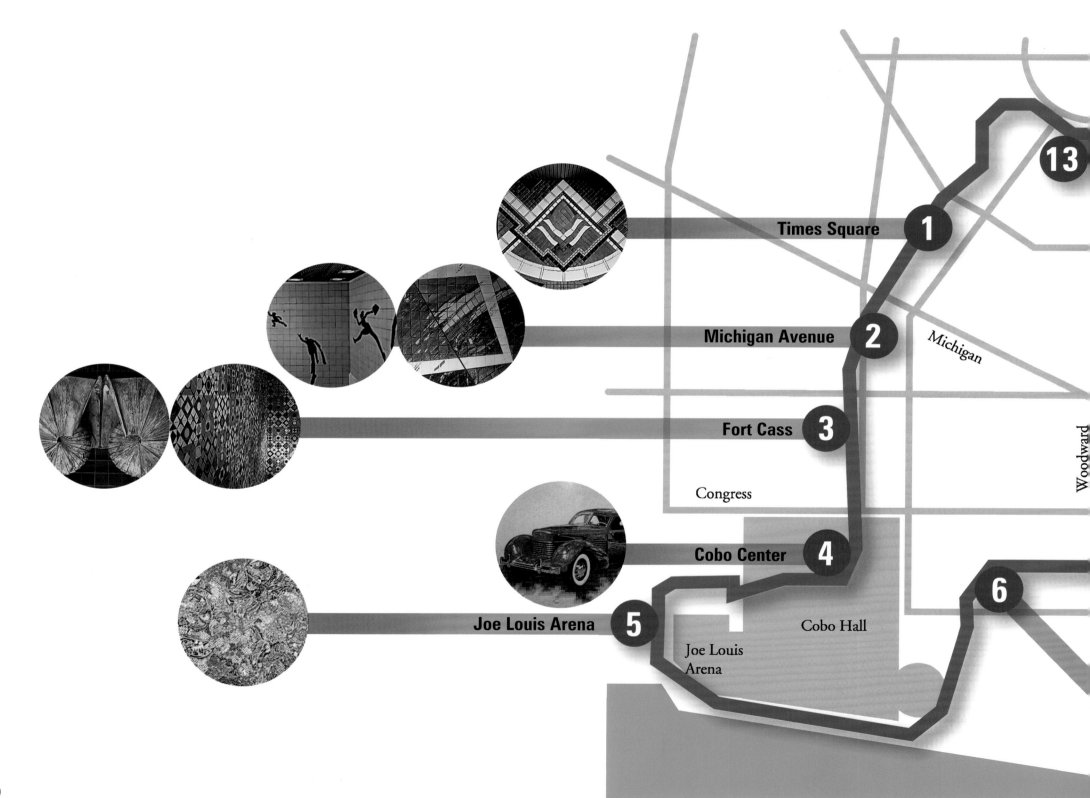

Times Square 1

Michigan Avenue 2

Michigan

Fort Cass 3

Congress

Woodward

Cobo Center 4

Cobo Hall

Joe Louis Arena 5

Joe Louis
Arena

6

13

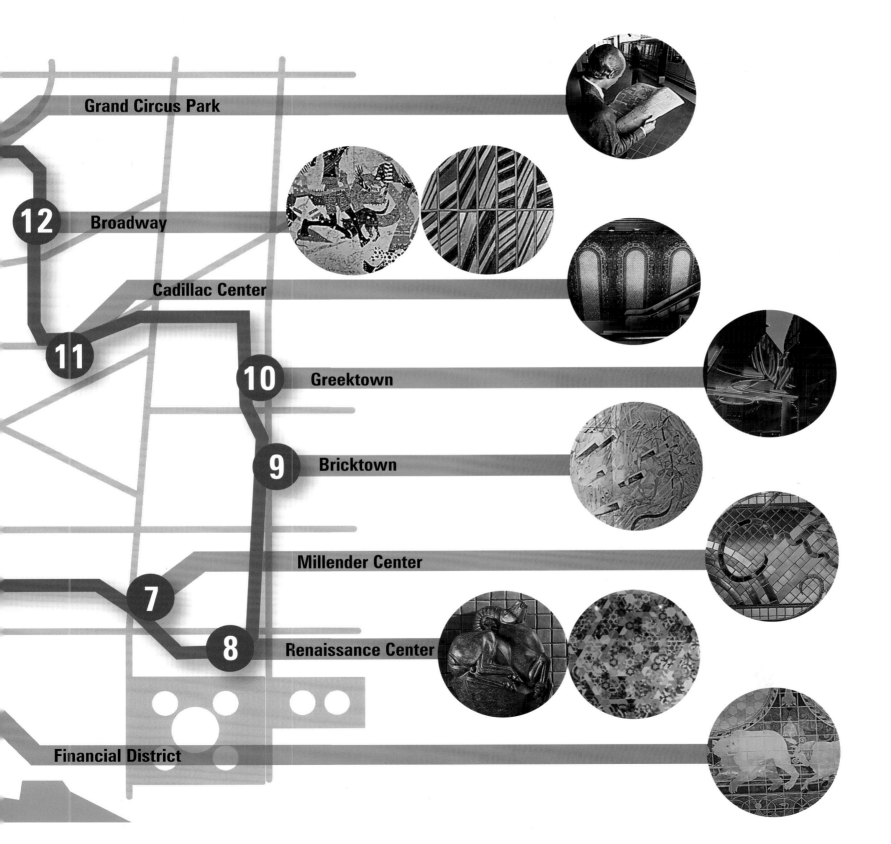

**Grand Circus Park**

**12** Broadway

Cadillac Center

**11**

**10** Greektown

**9** Bricktown

Millender Center

**7**

**8** Renaissance Center

Financial District

11

# The Stations

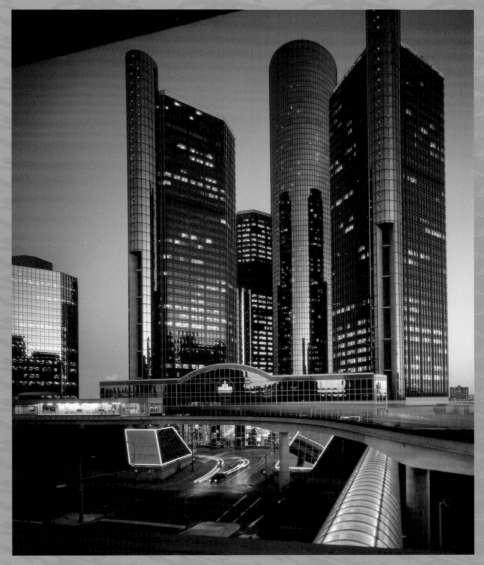

Photos by Balthazar Korab

# Times Square

*Untitled*

**Anat Shiftan
Pewabic Pottery**

Funded by the Detroit People
Mover Art Commission

224 tiles
Pewabic Pottery tile
4" square

Anat Shiftan, then the chief designer at Pewabic Pottery, created this art work to honor the efforts, achievements, and legacy of the Art in the Stations Commission. Located in the People Mover's "Mother Station," it also serves to welcome passengers to Detroit's elevated transit system.

This mural incorporates tiles that feature the "Art in the Stations" logo, which had been designed by Larry Ebel. The tiles had been produced in 1987 to commemorate the opening of Art in the Stations.

This work was one of three added to the collection in 1992.

Times Square Station houses the People Mover's headquarters and control center. The maquettes, the artists' renditions of their proposed works, are on display within the headquarter offices.

# Times Square

*In Honor of*
*W. Hawkins Ferry*

**Tom Phardel**
**Pewabic Pottery**

Funded by W. Hawkins Ferry,
Detroit Council for the Arts,
Michigan Council for the Arts,
Detroit Edison, City of Detroit,
Detroit People Mover Art
Commission

Pewabic Pottery tile
49' 10" x 10', 800 sq. ft.
12' 8" x 12' 10", 163 sq. ft.

Sculptor Tom Phardel, then a faculty member at Pewabic Pottery, created a contemporary design for the Times Square Station, but one sensitive to Pewabic's arts and crafts tradition. Although the bold, vivid colors of this work are not part of the Pewabic palette—the yellows were particularly difficult to duplicate—the geometric patterns of this work evoke the Pottery's art deco heritage.

Because Times Square contains the headquarters of the People Mover system, it was the first station completed. Unlike the other artists involved in Art in the Stations, Phardel faced the challenge of creating art for an existing and overwhelmingly large space. He had to design his works around the tile and brickwork already in place.

Two murals were created for this station. The first is viewed upon entering the turnstiles. After turning the corner toward the escalator, the second, larger mural comes into sight.

As you ride the escalator up to the train platform, the intensity of color and form increases to monumental proportions.

This work honors W. Hawkins Ferry for his tireless efforts on behalf of the Detroit People Mover Art Commission. An avid art collector and supporter of the arts, Mr. Ferry was instrumental in securing significant and important public works for the city of Detroit, including Isamu Noguchi's fountain and pylon in Hart Plaza; John Chamberlain's sculpture *Deliquescence* on the Wayne State University campus; and Robert Graham's tribute to Joe Louis on Jefferson Avenue. A third-generation Detroiter, Hawkins Ferry was also an architect, architectural historian, and author. His grandfather, Dexter Mason Ferry, founder of the Ferry Seed Company, also founded The Detroit Museum of Art, predecessor to The Detroit Institute of Arts.

# Michigan Avenue

*Voyage*

## Allie McGhee

Funded by Michigan Council for
the Arts, Community Foundation of
Southeastern Michigan, Michigan
Bell (an Ameritech Corporation),
City of Detroit, Detroit People
Mover Art Commission

Pewabic Pottery tile
17′ x 12′

Detroit artist Allie McGhee recreated his vibrant painting *Voyage* in tile with the assistance of Pewabic Pottery and a grant from the Michigan Council for the Arts. The colors, textures, and shapes he uses in his paintings—reflecting the harmonies of image, rhythm, light, and motion—translate beautifully into the more durable medium.

McGhee was initially taken aback by the unpredictability of the glazing process. As a painter he was accustomed to applying the exact color he wanted onto a canvas. But when working with tile, the artist had to envision the color the glazes would become after the clay had been fired. McGhee eventually found "a very painterly way" to work with glazes, and so was able to capture the characteristic spontaneity of his work in ceramic. *Voyage* is constructed of 600 tiles, each a painting in itself.

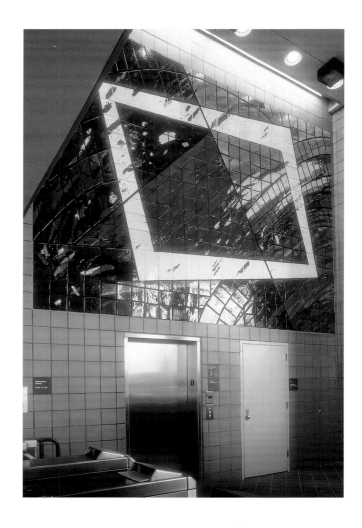

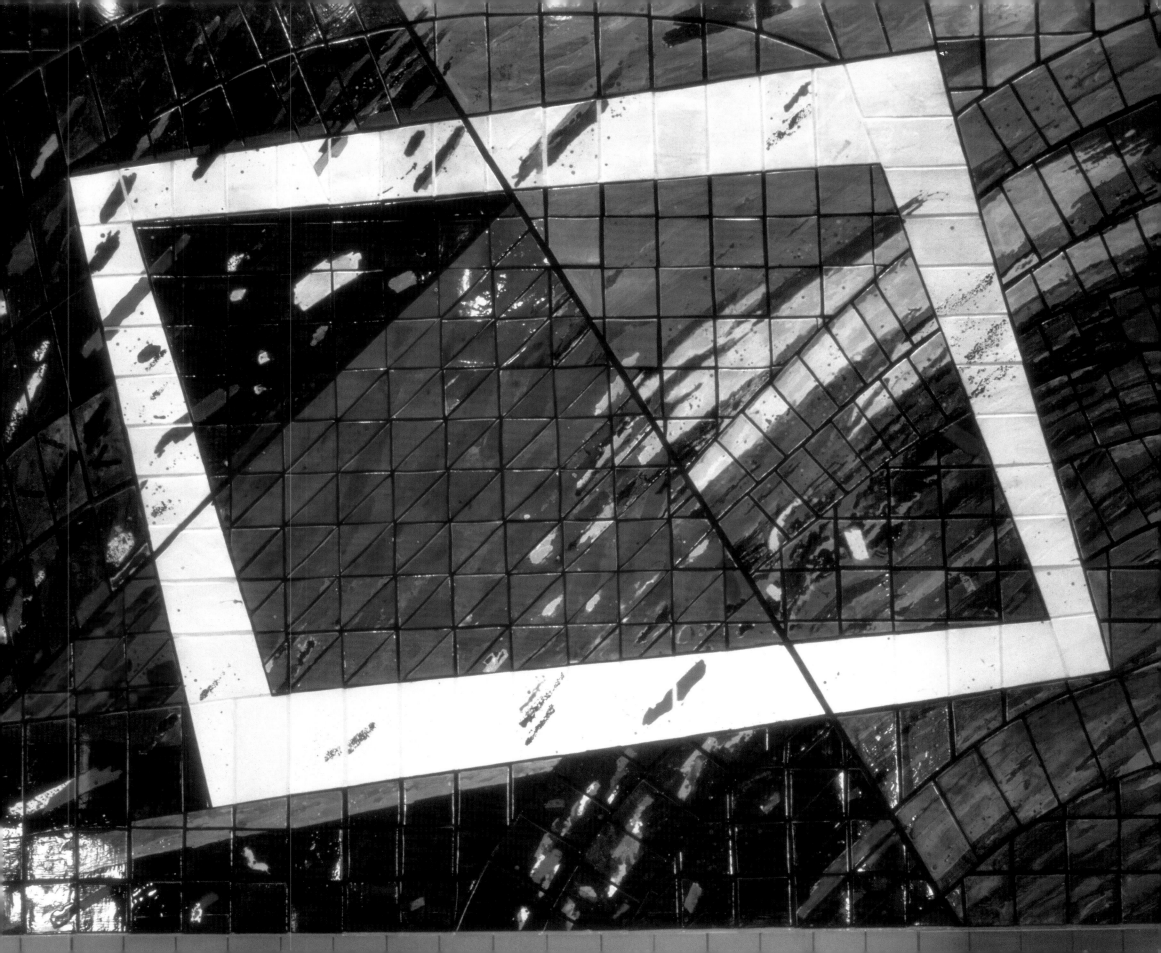

# Michigan Avenue

*On the Move*

**Kirk Newman**

Funded by Michigan Council for the Arts, City of Detroit, Detroit People Mover Art Commission

Cast bronze
14 silhouettes
Longest span, 23'

Sculptor Kirk Newman's fourteen bronze silhouettes race up and across the walls of Michigan Avenue Station, filling it with life and activity in pantomime of People Mover passengers.

The cast bronze figures are only one-eighth inch thick, but their placement—slightly removed from the wall—adds dimension and enhances the impression of constant movement. The largest figure, striding along the escalator wall with a 23-foot span, visually carries you up to the platform level in one long step.

Newman envisioned the commuters as fast-moving and frenetic. Through their actions, he expresses their concerns and apprehensions: the executive faced with overwhelming tasks; the working mother worried about her child; the stressed employee juggling multiple briefcases. In focusing on the shadow rather than the individual, Newman's seemingly humorous approach hints at the darker aspects of too-busy lives.

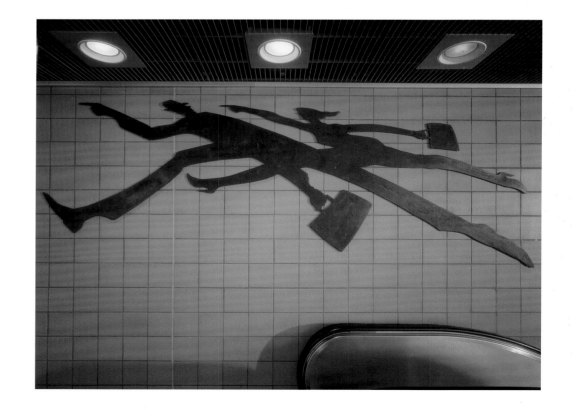

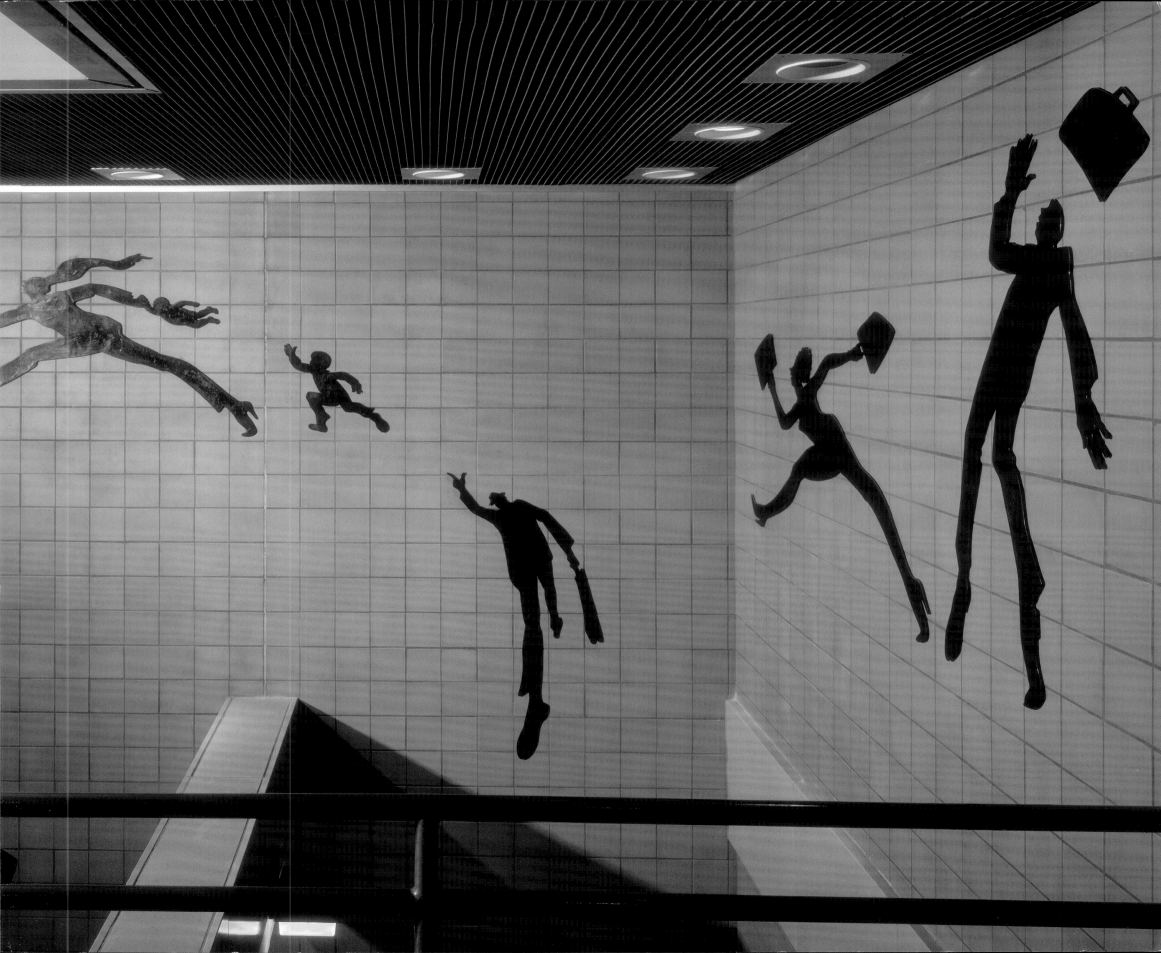

# F o r t / C a s s

Sandra Osip's mirror-image bronze sculptures provide a fascinating study of life in a factory town. In three dimensions, she examines the conflict and compatibility of nature within an industrial environment.

A native Detroiter, Osip draws on her hometown perspective in this work. The organic shape of the sculptures combines and contrasts with the materials of their construction. Built of bent metal and rivets, these natural forms evoke both harmony and discord. Calming and challenging, the graceful sculptures bring to mind seashells and medieval armor. She has merged the disparate to a very positive effect.

This is one of three works added to the Art in the Stations collection in 1992.

*Progressions II*

**Sandra Osip**

Funded by Detroit People Mover
Art Commission

Bronze
Two sculptures
6' x 10' x 20" each

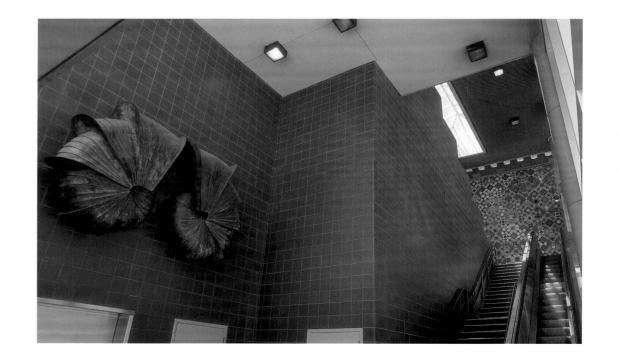

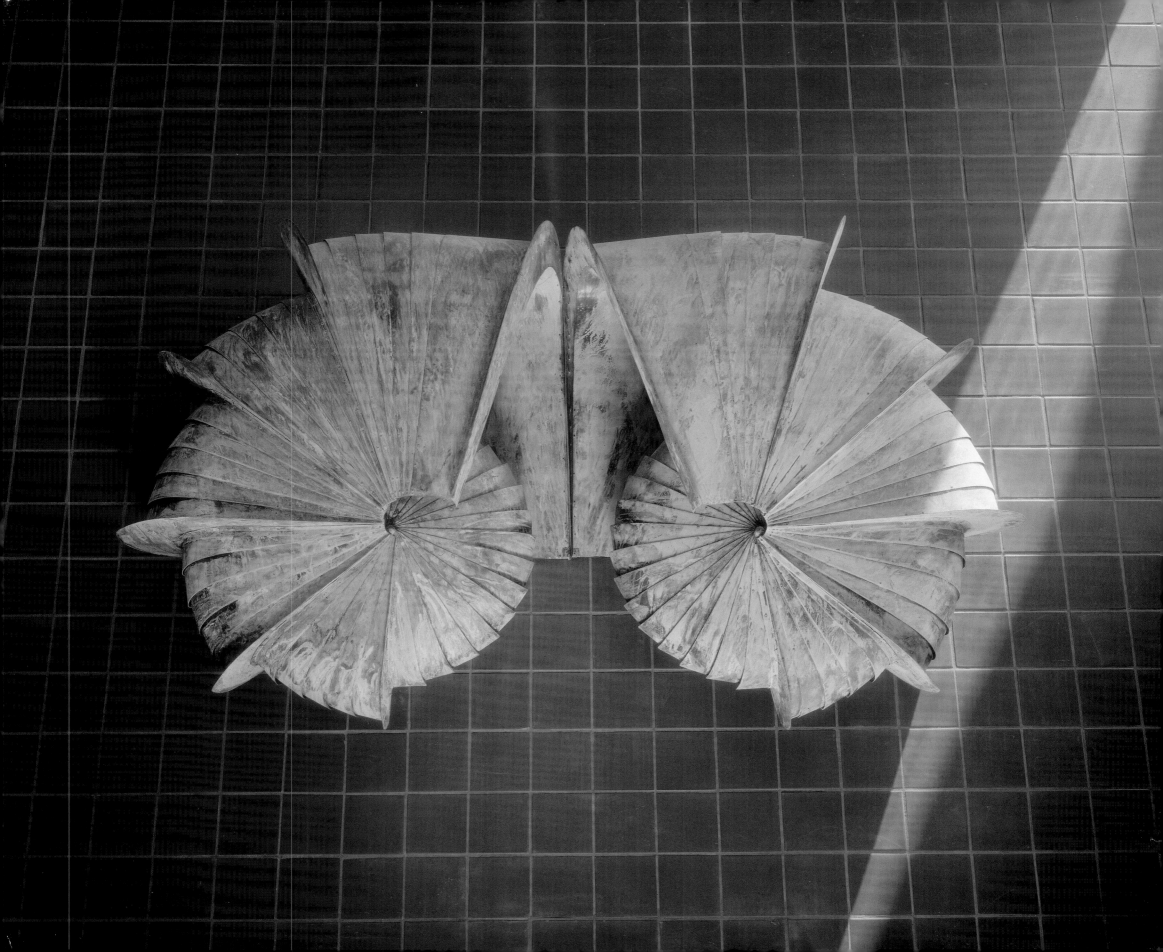

# Fort/Cass

*Untitled*

## Farley Tobin

Funded by The Skillman Foundation, Philip Graham Fund (WDIV and Newsweek), Knight Foundation, City of Detroit, Detroit People Mover Art Commission

13,884 tiles
1,300 sq. ft.

Farley Tobin's magnificent and complex murals integrate so thoroughly with the architecture of the station that the art and the station have become one. Robert Jensen, then curator of the American Craft Museum, called Farley Tobin's Fort/Cass Station work "the best example of art in architecture anywhere."

Her beautiful geometric patterns are reminiscent of Islamic design. The variations, from bold to subdued, engage the mind and the eye of the commuters waiting in the station as well as those riding the train.

Her design involves two pattern units: one with a square center and one with a circular center, both fitting into a 16-inch square grid. The striking resultant red "X" configuration captures immediate attention, and serves to draw the viewer into the subtleties of the piece.

A highly regarded public artist, Tobin appreciated her early involvement in the project: Her work, she said, "looks like it belongs and was planned for from the beginning—not as an afterthought, as so often happens in public art."

This work was selected for inclusion in the American Craft Museum's 1988 exhibit "Architectural Art: Affirming the Design Relationship."

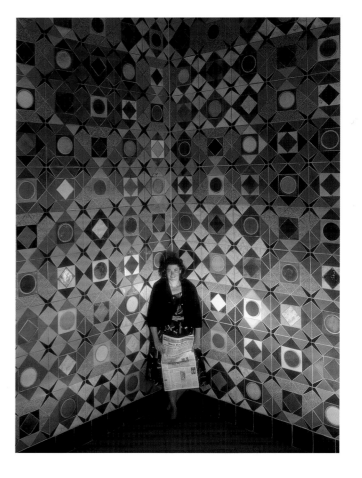

# C o b o   C e n t e r

*Cavalcade of Cars*, designed by Larry Ebel and Linda Cianciolo Scarlett, covers the entire wall across from the Cobo Center Station platform. This strikingly realistic depiction of seven vintage automobiles, expertly executed in Venetian glass mosaic by Crovatto Mosaics, is luminously photographic in its representation.

A tribute to the Motor City, this massive mural features a 1949 Chrysler, 1936 Cord, 1955 Thunderbird, 1931 Model A Ford, 1931 Chrysler, 1957 Chevrolet, and 1948 Buick. The vehicles were selected from Carrail, the private collection of Detroit businessman Richard Kughn, and photographed by Gary Ryan.

The mural was created in the workshops of Crovatto Mosaics in Spilimbergo, Italy, an ancient and renowned center of the mosaicist craft. Cosante Crovatto, who oversaw the work's production, delivered mural-sized photos of the individual automobiles to various artisans who then replicated them in glass.

The Spilimbergo craftspeople set mosaics by the "reverse" or "indirect" method. In this approach, the glass fragments are set rightside-down into a flour and water glue and placed on paper. When the piece is installed, the exposed back of the mosaic is set into a freshly cemented wall. The paper is removed, excess glue is sponged away, and the smooth glass face of the work is revealed.

However, because its location—opposite the platform and across the tracks—removed the possibility of commuter contact, the mosaicists could use the rough, potentially dangerous, side of the glass pieces when reproducing the automobiles. The nonuniform and jagged edges bring extra depth and dimension to the finished work, which is enhanced to dramatic effect by directed lighting.

Cobo Center is one of the busiest stations on the People Mover route, depositing conventioneers, trade show traffic, Detroit Auto Show visitors, and others to the Cobo Hall facilities. The station was already in operation when the murals arrived from Spilimbergo, so installation had to take place between the hours of midnight and 6 a.m., when the trains were not in operation.

*Cavalcade of Cars*

**Larry Ebel &
Linda Cianciolo Scarlett**

**Fabricated by
Crovatto Mosaics**

Funded by The Chrysler Motor Fund,
The Ford Motor Fund,
The General Motors Foundation

Venetian glass mosaic
105' x 10'

Opposite: 1955 Thunderbird
Overleaf: 1957 Chevrolet (left)
1949 Chrysler (right)

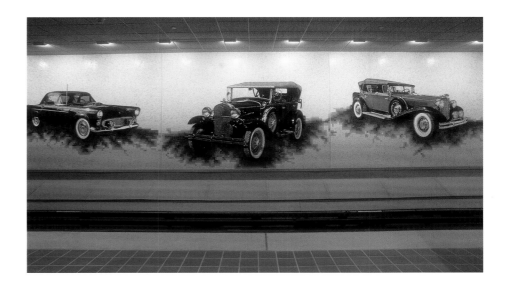

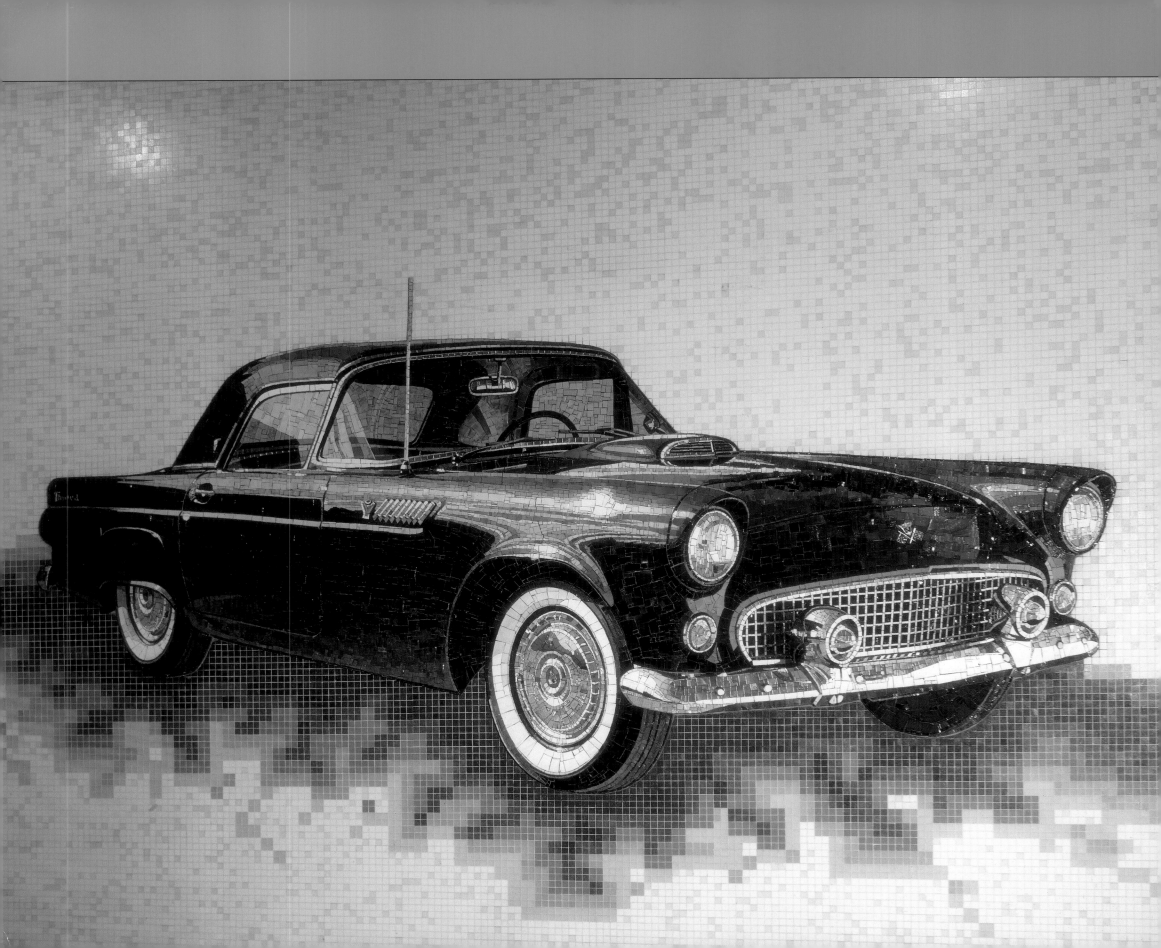

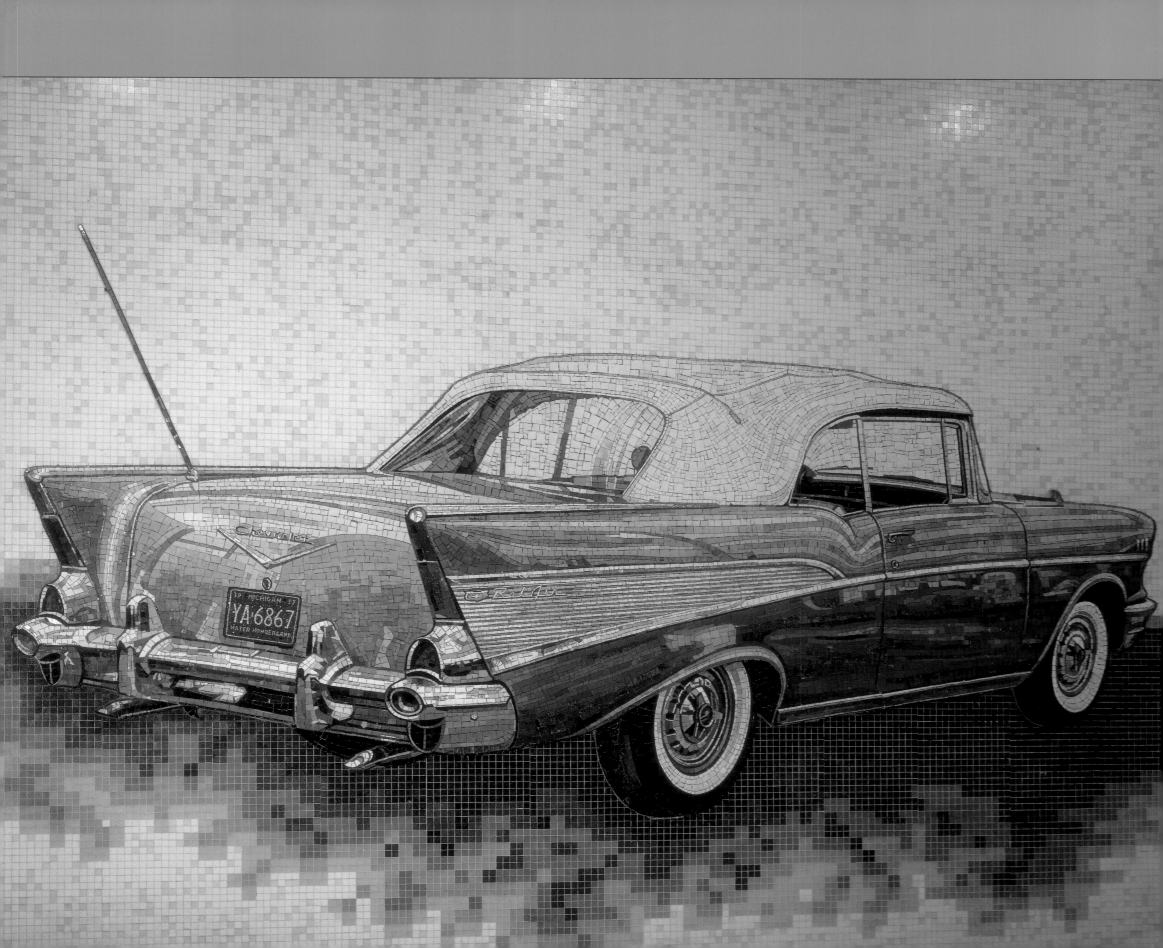

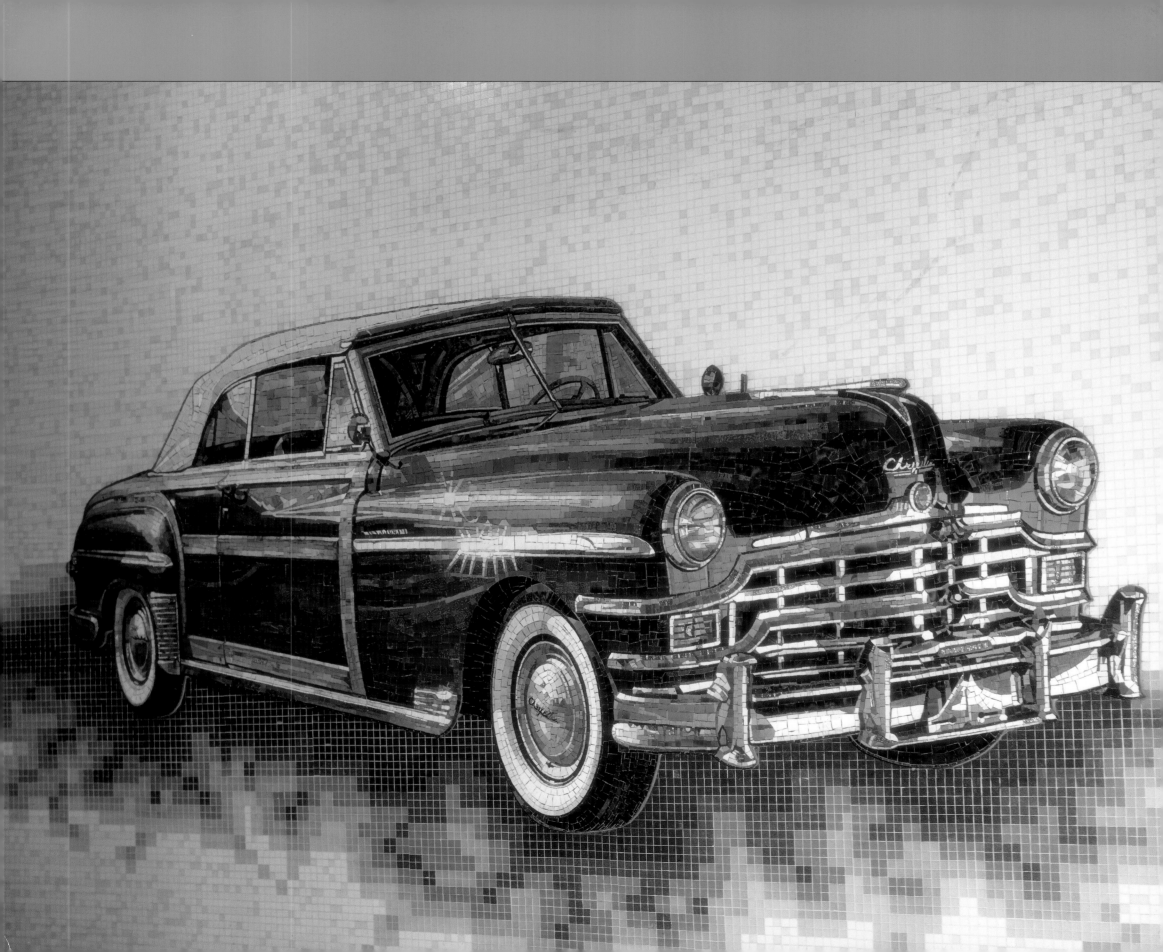

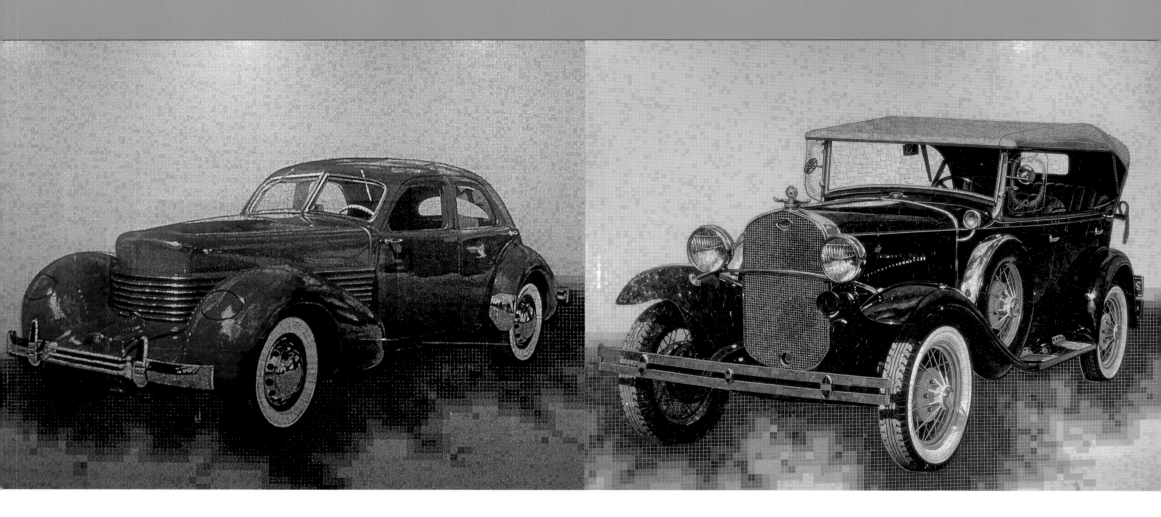

Left to right:
1936 Cord
1931 Model "A" Ford
1931 Chrysler
1946 Buick

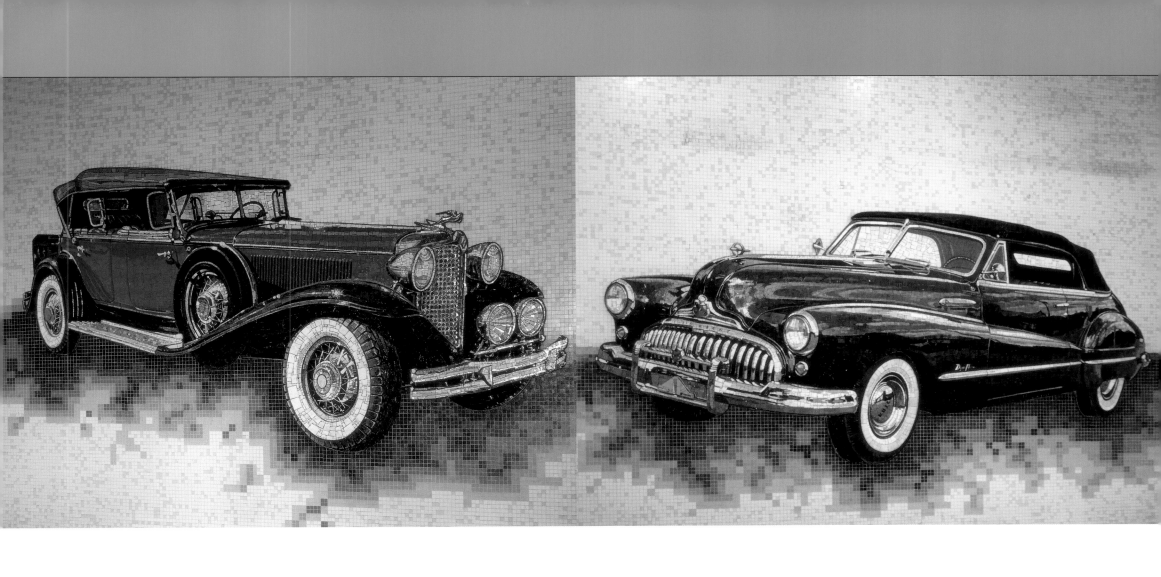

# J o e  L o u i s  A r e n a

Gerome Kamrowski's sparkling two-part mosaic *Voyage* brings "a wall of iridescence" to this heavily trafficked station, which provides access to Joe Louis Arena, home of the Detroit Red Wings hockey team.

A famed surrealist of the 1930s and 1940s, Gerome Kamrowski studied at New York's Art Students League and the New Bauhaus School in Chicago. His works are often constructed of enticing materials—pearls, colored stones, and other fanciful, and detachable, items. Because that approach is not suited to art in the public place, Kamrowski allowed his work to be created in Venetian mosaic in Spilimbergo, Italy, by Crovatto Mosaics. The shimmering glass fragments perfectly capture and reflect the spirit and lightness of his work.

To replicate the work in mosaics, versions of the two murals were rendered in reverse. These reverse copies were then cut into two- and three-foot square sections, following the contour of the design to avoid the detection of joints. The resulting 45 sections for each mural were distributed among the mosaicists in Spilimbergo. Using the reverse mosaic method described earlier (see Cobo Center Station), the artisans reproduced each section in mosaic. As they were completed, the sections would be arranged in place, and the balance of colors throughout the piece appraised.

*Voyage* is Kamrowski's interpretation of a seventeenth-century astrological map. Since constellations have been guiding travelers throughout the ages, this work is an especially appropriate choice for a transit station.

*Voyage*

**Gerome Kamrowski**

Fabricated by
Crovatto Mosaics

Funded by A. Alfred Taubman,
Michigan Council for the Arts, Detroit
People Mover Art Commission

Venetian glass mosaic
12' x 7', 84 sq. ft.
15' 8" x 7', 110 sq. ft.

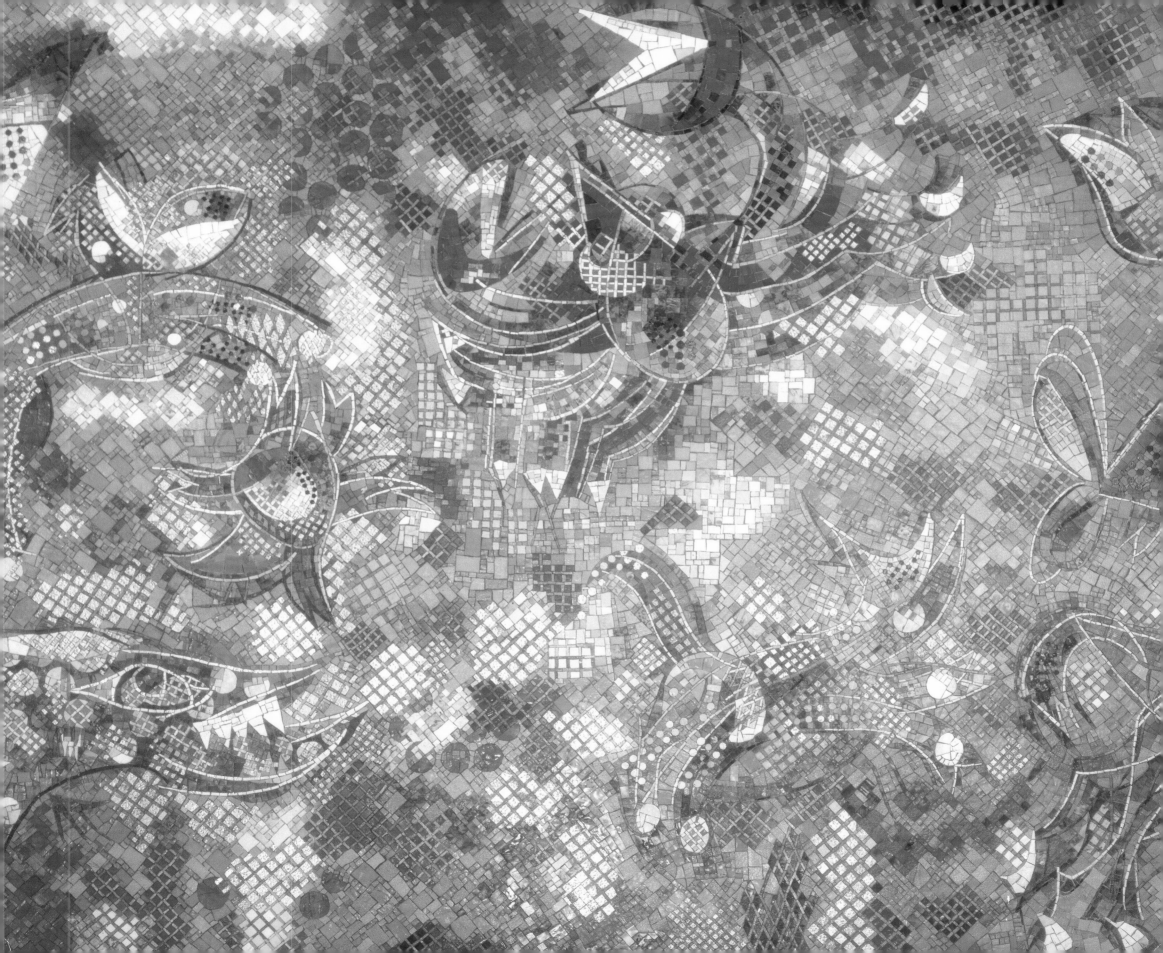

# Financial District

*"D" for Detroit*

**Joyce Kozloff**

Funded by Kohler Art Center,
National Endowment for the
Arts, MichCon Foundation,
Gannett Foundation and the
Detroit News/Gannett Outdoor,
Turner Construction Company,
The City of Detroit, Detroit
People Mover Art Commission

Approximately 1,200 tiles
1,200 sq. ft.

Joyce Kozloff captured multiple elements of Detroit in her beautiful Financial District Station mural. The bull and bear symbolize the Detroit Stock Exchange, which had once stood on the station's site. She incorporated elements of James MacNeill Whistler's Peacock Room, which had been moved from England to the Detroit home of industrialist Charles Lang Freer in 1904. In delicate contrast to these robust images of finance, she created a three-story centerpiece "D" in the manner of a large illuminated manuscript.

Kozloff, who is also a painter, works in small scale when creating her watercolors and in very large scale for her public art commissions. In this piece, she decided to combine the two, taking "something that would ordinarily be a miniature and making it gigantic."

The artist often creates her hand-painted tiles in her studio. But concern about the effects that Detroit's weather would have on her low-fired, porous tiles—the upper platform of this station is open to the elements—Kozloff decided that a less porous, more durable, high-fired tile was required. Awarded a six-month residency at The John Michael Kohler

Arts Center in Sheybogan, Wisconsin, which is sponsored by The Kohler Company, she produced her 1,200-tile work there. Her tiles were fired to a very high temperature, along with Kohler's porcelain plumbing fixtures, with industrial-strength results.

This work was selected for inclusion in the American Craft Museum's 1988 exhibit "Architectural Art: Affirming the Design Relationship."

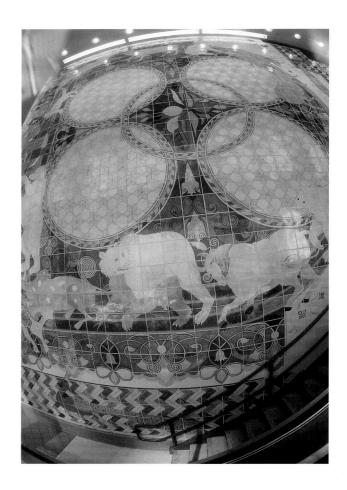

# Millender Center

A native Detroiter, Alvin Loving, Jr., is an abstract artist who has liberated his paintings from the constraints of the traditional rectangular format. He treats his works as constructions, an approach he applied when recreating this work in tile. To create a feeling of "rain . . . a splash, spray in your face," Loving used a broom to apply the colors.

A Guggenheim Fellow, Loving received a Michigan Council of the Arts Grant to study ceramics at Pewabic Pottery. He, like Allie McGhee, had not previously worked in clay.

Loving decided he wanted to create something "very beautiful" and accessible for Art in the Stations: "I wanted it to be something that a two-year-old kid can look at and like, and an 80-year-old retired postal worker can look at and like, and that I could look at and like."

*Detroit New Morning* is not constrained by its borders. Its pristine pastels are shot through, and beyond, with iridescent gold and streaks of bold color. It emanates joy and promise.

Impressed by the beauty of the murals, the owners of the Millender Center decided to replace the tile surrounding Loving's two works to provide a background that would better complement the art.

*Detroit New Morning*

**Alvin Loving, Jr.**

Funded by Forest City Enterprises/ Millender Center Associates, City of Detroit, Detroit People Mover Art Commission

Pewabic Pottery tile
5,000 tiles

36

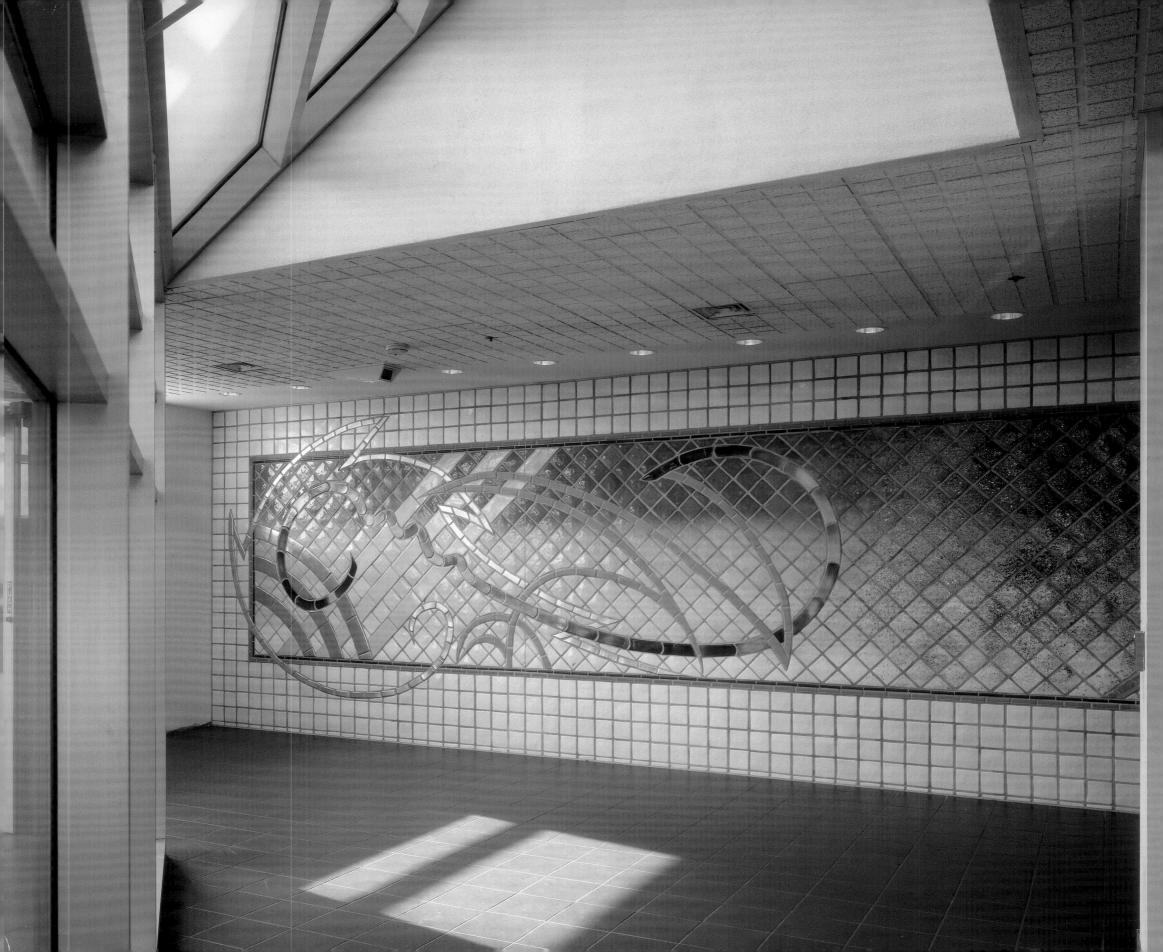

# Renaissance Center

*Siberian Ram*

**Marshall Fredericks**
**(1908–1998)**

Funded by Detroit People Mover
Art Commission

Cast bronze sculpture
Pewabic Pottery tile from
the Stroh donation

Michigan sculptor Marshall Fredericks' *Siberian Ram* stands before an elegant arched backdrop of Pewabic Pottery tile donated by the Stroh family. The artist coordinated the final bronzing of the piece to match the lush green hue of the historic tile. The silent strength and the soothing presence that emanates from the sculpture, enhanced by the merging tones of the tile and bronze, impart a sense of stability and endurance.

Fredericks, who studied and taught at the Cranbrook Academy of Art, earned an international reputation by creating monumental public sculptures. His 26-foot-tall *Spirit of Detroit*, which sits in front of Detroit's City County Building, has become a symbol of the city.

The original Renaissance Center Station was demolished in 2002 during General Motors' renovation of the complex. The *Siberian Ram* is relocated in the new station, surrounded by five walls of George Woodman's *Path Games*, installed in 2004.

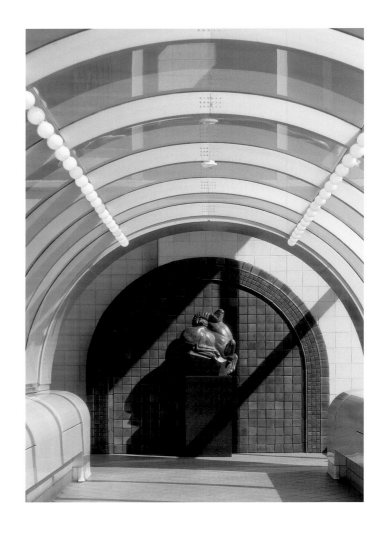

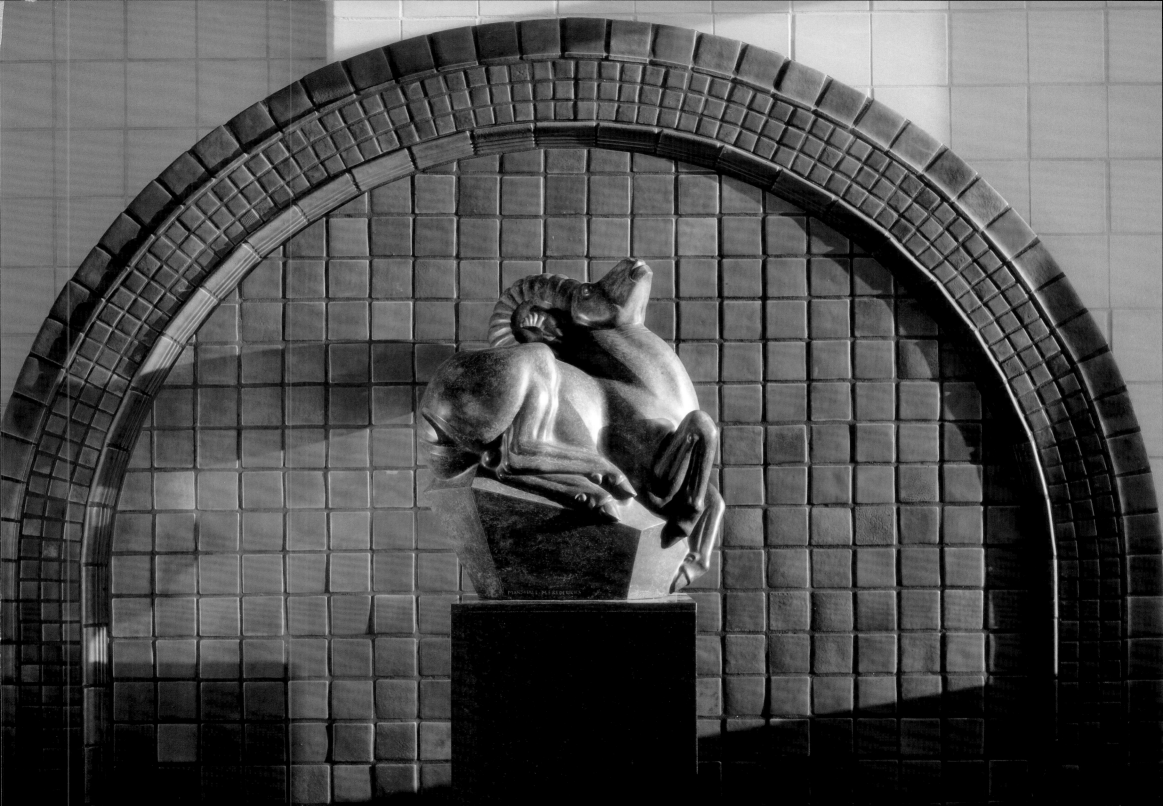

# Renaissance Center

*Path Games*

**George Woodman**

Funded by General Motors

Approximately 2,625 dry-pressed industrial tiles made by Franco Pecchioli SRL in Borgo San Lorenzo, Italy

An abstract painter, photographer, and ceramist, George Woodman believes public art should be interesting enough to engage people who see it every day. This is his eleventh project in tile and second in a People Mover station. His first installation, *Dreamers and Voyagers Come to Detroit*, was situated in the Renaissance Center Station and was demolished when General Motors and the City of Detroit rebuilt the station in 2004.

*Path Games* evolves from the design of the original installation and in Woodman's words is "a legitimate descendant" of it. However, it differs from the original in several ways. The original mural was composed of hexagonal tiles whose six sides permitted many hundreds of variations in the way the tiles were combined; the complex arrangement of diagonal, horizontal, and vertical rows gave the mural an explosive energy.

When Woodman undertook the design of the new installation, high-quality hexagonal tiles were no longer available. Moreover, the dimensions of the new station could not have accommodated the dynamism of the hexagonal patterns—the old station was on an outdoor platform with a high, lofty space; the new one has a low ceiling and tight proportions. Woodman therefore chose to work with 8" x 8" tiles, grouping them into four tiles and creating

modules 16" square. The design is based on a technique that Woodman developed in which a tile can be placed in any of its four orientations and still generate a continuous pattern; the technique allows for a remarkably large number of combinations. The way in which the modules are arranged re-creates some of the energy of the original mural but on a scale appropriate to the new space.

The coloring of the tiles is also evocative of the original mural, although the combinations and impact are quite different. Most tiles have two colors, one for the background and one for the straight and curved lines that play "path games" across the tiles. The color combinations vary throughout. About one in every ten tiles has no line at all and is simply a solid block of color. Woodman likens these tiles to rests in music and has used them to articulate the rhythm in this work of art.

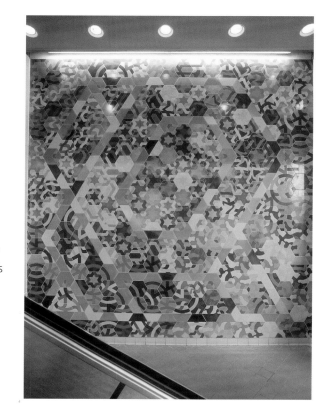

*Dreamers and Voyagers Come to Detroit*, George Woodman's original installation at the Renaissance Center Station. The installation was demolished when the station was rebuilt in 2004. *Path Games* (opposite page) has replaced the original installation.

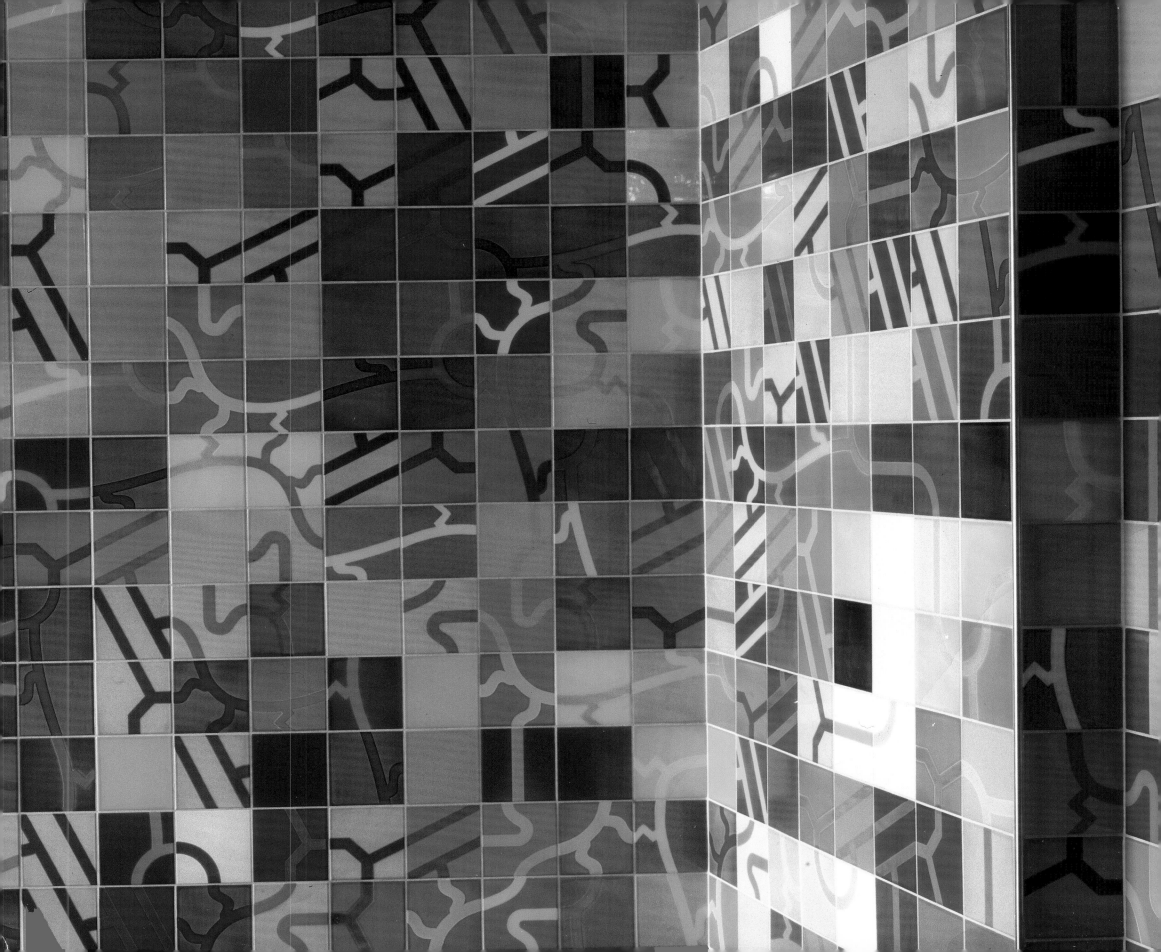

# Bricktown

*Beaubien Passage*

**Glen Michaels**

Funded by The Kresge Foundation

Fired enamel & steel
3 panels, 45' x 5' each

Architectural sculptor, painter, and musician Glen Michaels usually works in exquistely detailed bas relief. The materials he uses—bronze, glass, tile, stone, and wood—bring multiple dimensions and fluidity to his work.

For Art in the Stations, however, Michaels had to render his work in a more durable material. He chose fired porcelain because it allowed him to maintain his hallmark intricate detail and to enhance it with brilliant strips of color. His artistry overcame the one-dimensionality of the medium, instilling depth and cadence to the piece.

The images in *Beaubien Passage* capture a visual melody with an economy of form. The white panels with their black linear designs are reminiscent of railroad tracks; the elegant weavings of red and yellow ribbons, symbols of celebration, offer a sense of motion and story. The result is an exuberant aerial view of a city in motion: "little vignettes that are complete in themselves."

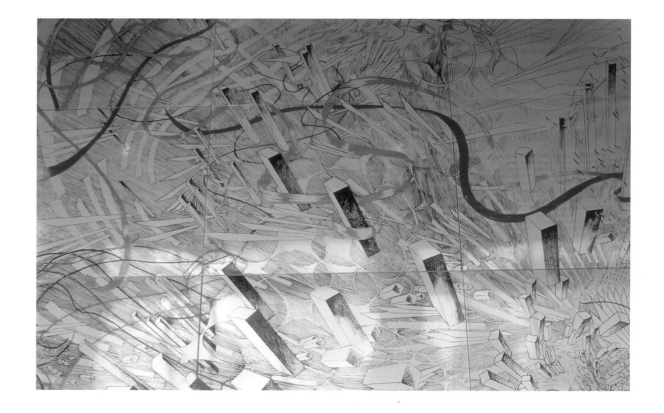

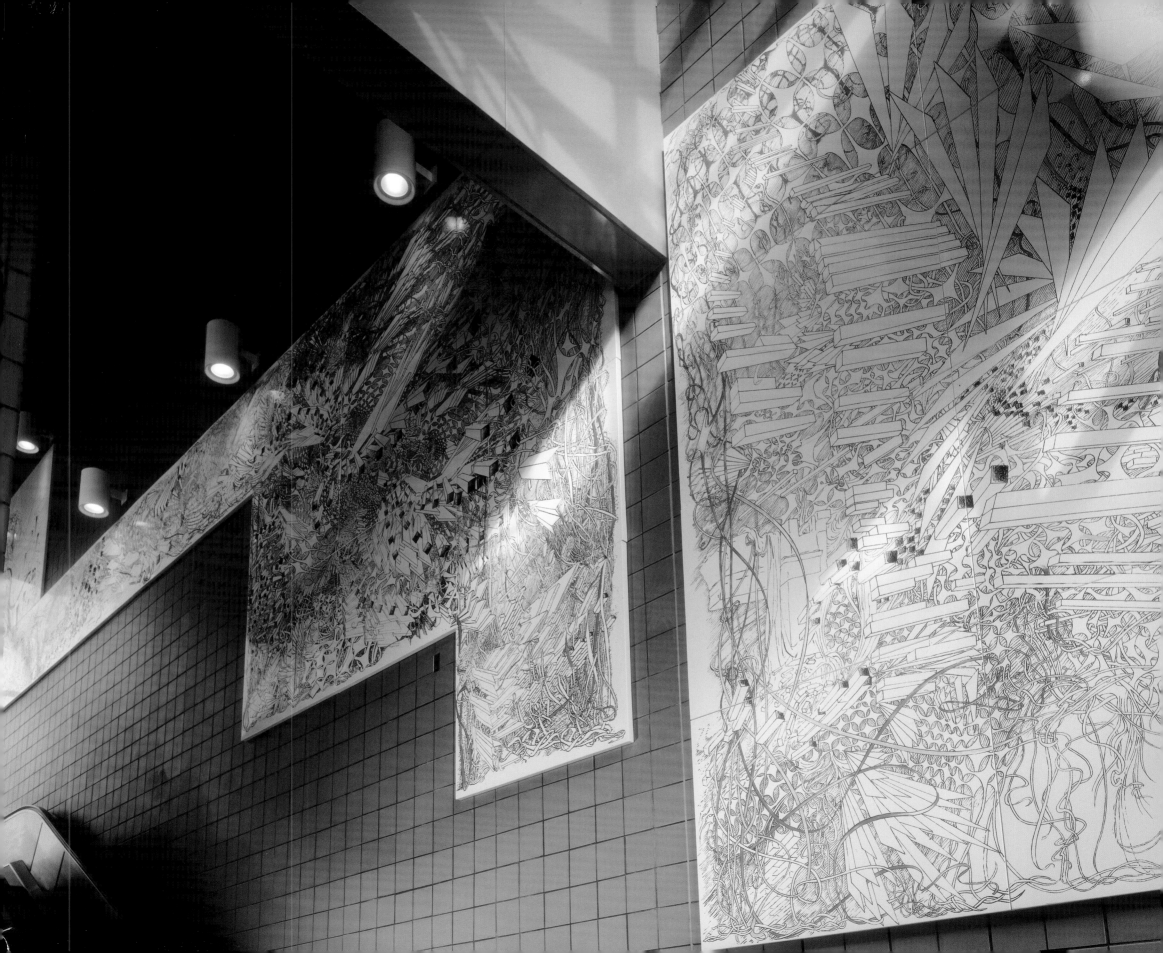

# Greektown

*Neon for the
Greektown Station*

**Stephen Antonakos**

Funded by Hudson's, Turner
Construction Company, Federal
Mogul, City of Detroit, Detroit
People Mover Art Commission

Stephen Antonakos, a pioneer in neon sculpture, combines minimal geometric forms with the fascinating luminescence of neon light. The contemporary commercial aspects of the material fuse his work to the architecture; the glow of the lighting melds his work with the surrounding space.

This is the only work in Art in the Stations that is located on the outside of a station's building. The racing, radiant colors that arch and circle, stretch and flex around and under the overhead station mimic the rhythm, and excitement, of being in transit.

People who take the train or walk by the station during the day have a different relationship to the work than those who pass by at twilight, when the day's light and the neon's light are in balance, or at night, when the contrasts are most extreme. Weather conditions compound the experience: the multi-colored reflections in rain puddles; the muted glow created by softly falling snow.

Antonakos wanted his piece to be "as joyful and colorful" as the surrounding Greektown area and his neon art enlivens a sterile station structure in this otherwise vibrant area. By blending with the existing signage of the busy streets, the sculpture melds the station into its neighborhood. Only upon reflection does the viewer realize there is no commercial intent in *Neon for the Greektown Station*—simply neon for the art and pleasure of it.

This work was selected for inclusion in the International Contemporary Art Fair, Yokohama, Japan, 1992

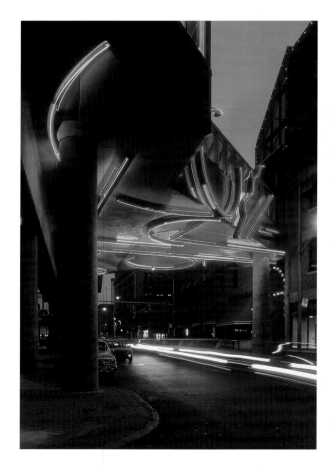

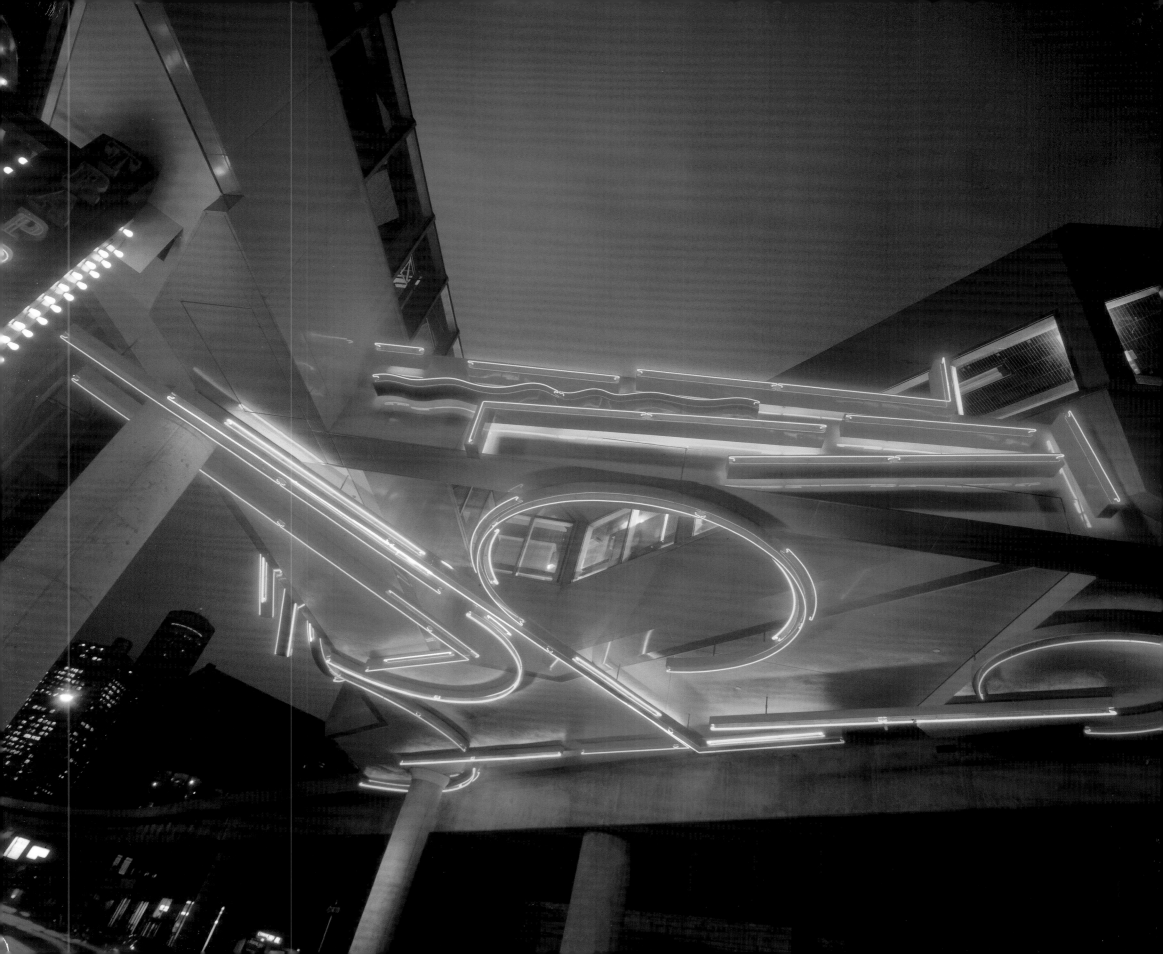

# Cadillac Center

*In Honor of*
*Mary Chase Stratton*

**Diana Pancioli /
Pewabic Pottery**

Funded by The Stroh Foundation,
Stroh Brewery Company, Walter
and Josephine Ford Foundation,
Michigan Council for the Arts,
City of Detroit, Detroit People
Mover Art Commission

Pewabic Pottery tile, including
26,000 tiles from the Stroh donation

53′ 2.5″ x 9′ 4″ to 19′ 6″ 625 sq. ft.
23′ x 19′6″, 449 sq. ft.
6′5″ x 9′4″, 59 sq. ft.

The majority of tiles used in the beautiful cathedral-like Cadillac Center Station were a gift from Peter Stroh. In the 1930s, Detroit's Stroh Brewery had commissioned Pewabic Pottery to create handmade architectural tiles for a planned new brewery. The facility was never built, however, and the tiles were put into storage. Many years later, when Mr. Stroh learned of Irene Walt's intent to beautify the People Mover stations, he offered the tiles to her.

Diana Pancioli, a Pewabic potter and designer, was presented with several unique opportunities when asked to design Cadillac Center Station, the largest of all Art in the Stations installations. Both the Stroh donation of Pewabic tile and a historic plaque commemorating the arrival of Madame Cadillac to Detroit were to be incorporated into its walls.

Her solution was to embrace the heritage of Pewabic Pottery and look to the design sensibilities of Pewabic founder Mary Chase Stratton for inspiration. Stratton frequently used arches in her work, so Pancioli made them the focal point of this elegant station. Surrounded by historic Pewabic tile, the luminous arches suggest stained glass windows, which seem to fill this otherwise windowless space with light. The murals have not been placed on the walls; they have become the station.

Within the arches, Pancioli positioned reproductions of the "Detroiters at Work" series that Mrs. Stratton had created in 1926 for Northern High School. The original molds were used to make these tiles, which form the piers that "support" the arches, thus adding an architectural metaphor to the tiles' historical significance.

Although over 26,000 Stroh-donated Pewabic tiles were used in the walls, there were not enough large cornice molding pieces to edge the ceiling. Duplicating the form was no problem, but the formula for the matte green glaze could not be found. Then Ms. Pancioli discovered a letter that Mary Chase Stratton had written to Gary Stroh decades before, in which she had said, "I am sending you the formula for safe-keeping." The Stroh Brewery archivist located the original letter—and the formula.

This work was selected for inclusion in the American Craft Museum's 1988 exhibit "Architectural Art: Affirming the Design Relationship."

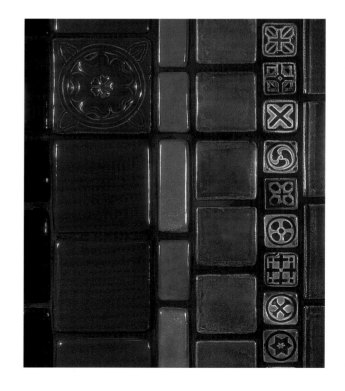

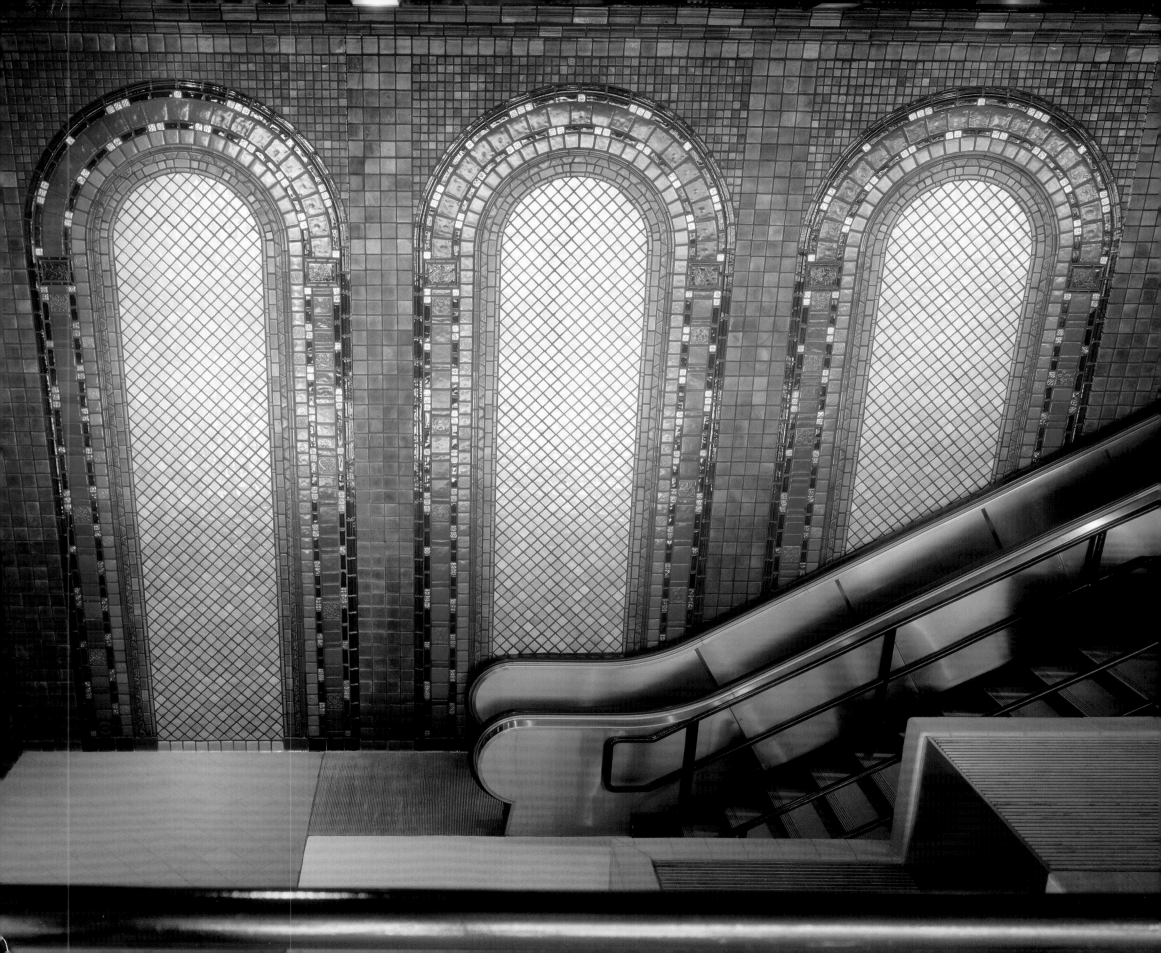

# Cadillac Center

*In Memory of Madame de la Mothe Cadillac*

**Carlo Romanelli**

Gift of the Woman's Bi-Centenary Committee to the City of Detroit, 1903; On loan from The Detroit Institute of Arts

Cast bronze
Alto releve
30" x 41"

This bronze tablet by Italian sculptor Carlo Romanelli depicts the arrival of Madame de la Mothe Cadillac in Detroit in 1701. Accompanied by her two young children, Madame Cadillac had traveled nearly one thousand treacherous miles from Quebec to join her husband, Antoine de la Mothe Cadillac, the founder of Detroit.

Commissioned by The Woman's Bi-Centenary Committee of Detroit in 1901, the tablet commemorates the 200th anniversary of the city's founding. Installed in The Detroit Museum of Art, it was unveiled May 31, 1903, in an impressive ceremony, complete with children's choirs and oratory. When that museum was razed in the 1920s for the construction of The Detroit Institute of Arts, the bronze was put into storage. On loan from The Detroit Institute of Arts, it was installed in Cadillac Center Station in 1987.

Carlo Romanelli was born in Florence, Italy, in 1872. There he studied with his father, Rafaello Romanelli, and with Augusto Rivalta, at the Royal Academy of Art. Romanelli moved to Detroit in the early 1900s; among his works are *La Pieta* at the entrance to Mt. Elliott Cemetery.

The bronze tablet depicting the arrival of Madame de la Mothe Cadillac is placed in the wall at the left side of the photograph.

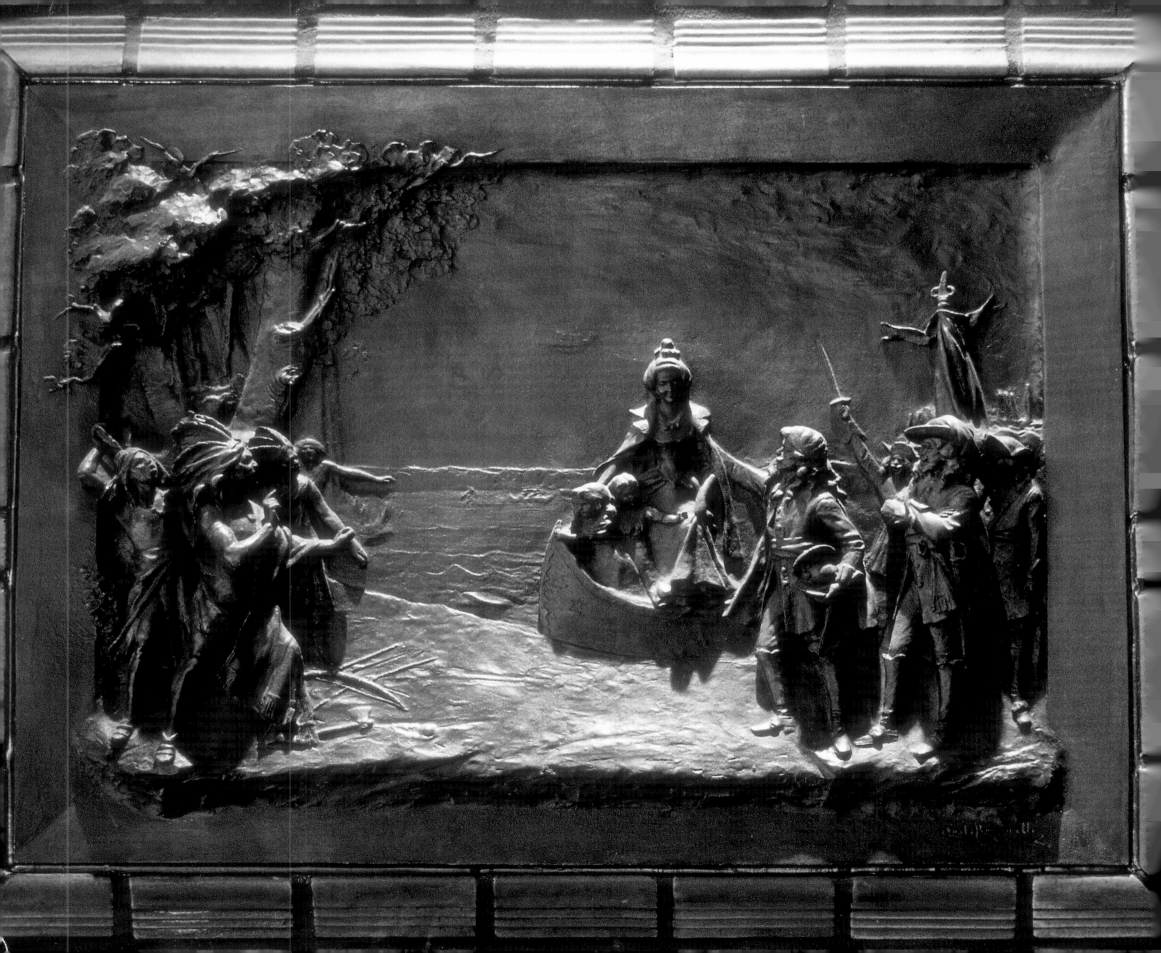

# Broadway

*The Blue Nile*

## Charles McGee

Funded by The Hudson Webber
Foundation, City of Detroit, Detroit
People Mover Art Commission

Outdoor enamel paints
on Alucobond

12' x 17'

Artist Charles McGee has not only made great contributions to the state of the arts in Detroit and Michigan, he has made tremendous contributions to the development of contemporary painting. His sophisticated abstract works reflect his love of the painted form and his personal and sensitive interpretation of the beautiful textures and colors of African art.

McGee drew *The Blue Nile* from his "Noah's Ark" series, which combines eclectic configurations of people, animals, and abstract elements with unusual surface treatments. In this piece, his imagery blends Western mythology with non-Western art. He incorporates human and animal forms with the same reverence and monumentality, depicting his belief that equality and community are necessary among all living things. Spontaneous and unpredictable, the beautiful and colorful dancing subjects—man, woman, child, and animal—create their own music.

Because it was created with outdoor industrial enamel paint on a metal surface, this is the most painting-like of all Art in the Station works.

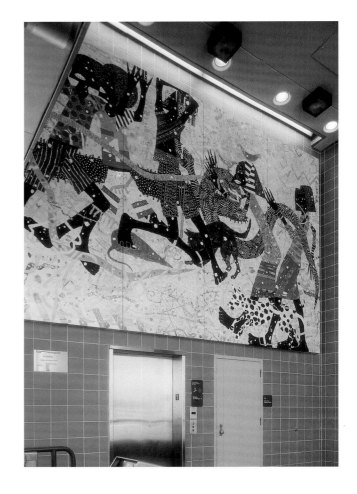

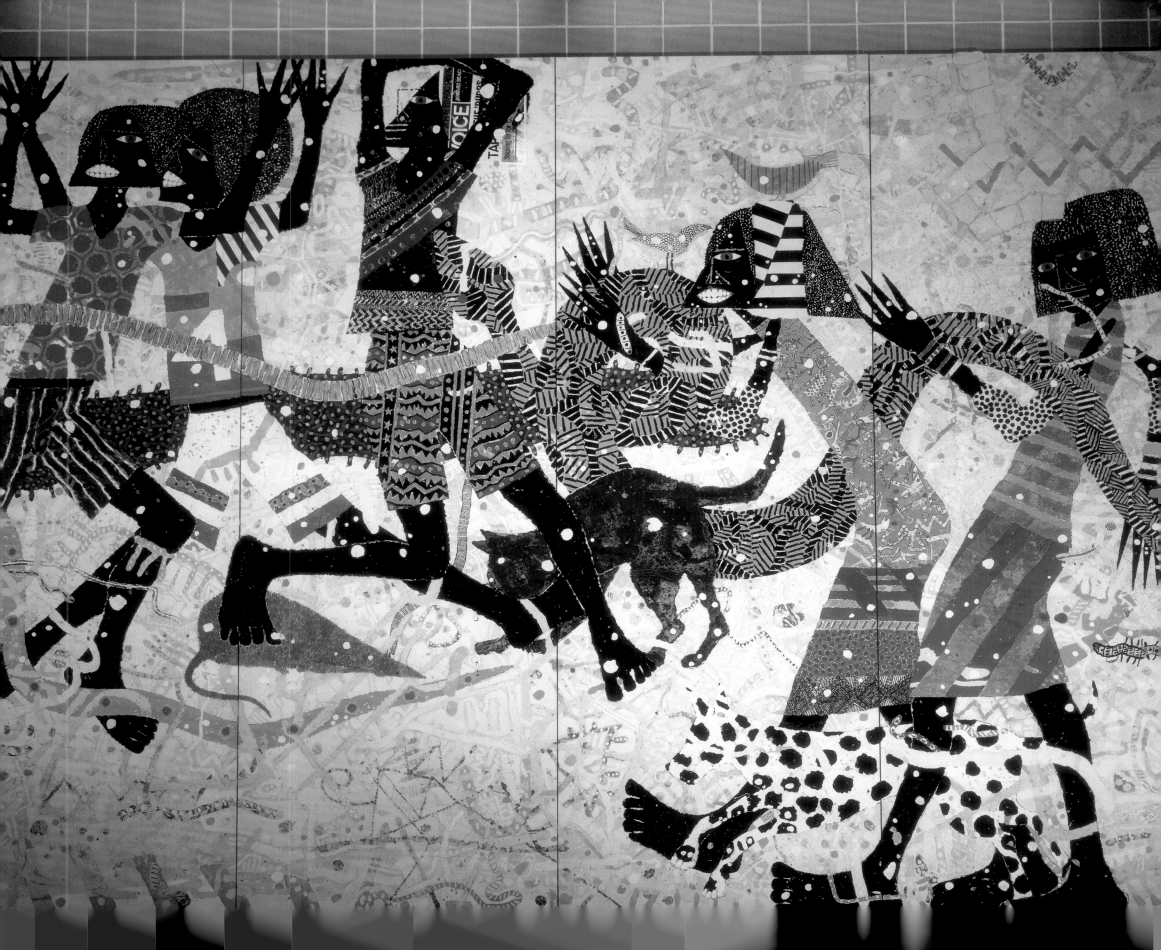

# Broadway

Jun Kaneko began his art career as a painter and became a ceramist after moving to the United States from Japan. He has received international recognition for his clay sculptures, notably the large, human-scale, pillow-like forms he calls "dangos" (which means dumplings in Japanese).

His mural for the Broadway Station is an extension of the surface study he explores in the dangos. The powerful and elegant patterns of his handmade tiles create a visual energy that transports clay to a new level of sophistication. His unmistakable style bridges Eastern and Western sensibilities of color and pattern and scale. The juxtaposition of activity and negative space in his unconventionally shaped tiles (5-1/2" x 22") suit the architecture of the station and the surrounding area.

Kaneko has an implicit understanding and respect for his medium and the process and pace of creation. He does not manipulate the elements, he works with them—a collaboration with profound and intense results.

*Untitled*

**Jun Kaneko**

Funded by The Hudson Webber Foundation, City of Detroit, Detroit People Mover Art Commission

Tile
23' x 20'10", 380 sq. ft.

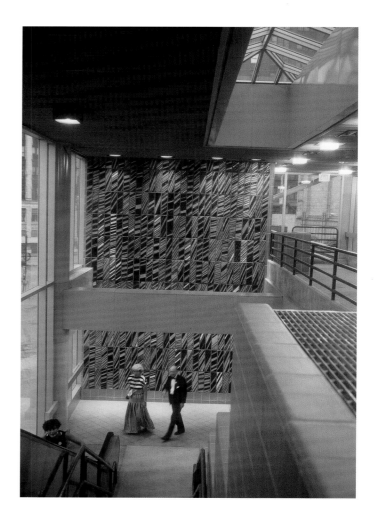

# Grand Circus Park

*Catching Up*

**J. Seward Johnson, Jr.**

Funded by: City of Detroit, Detroit People Mover Art Commission

Cast bronze
Life-size

J. Seward Johnson Jr.'s life-sized sculpture of a commuter reading a newspaper has caught more than one actual commuter offguard. Unofficially labeled the most popular of the Art in the Stations works, *Catching Up* reminds us that art doesn't have to confuse and evade us to be valid; art can be accessible—and it can be fun.

J. Seward Johnson, Jr., began his creative life as a painter, turning to sculpture in the late 1960s. He works exclusively in bronze, with the realism of texture and detail being his hallmark.

At first the Commission thought Johnson should create a Detroit Tiger baseball player, who would wait in the station in uniform, sportsbag at his side. However, it was soon determined that an ordinary citizen—an everyman—reading the newspaper would be a more appropriate choice. A coin toss determined that the commuter would be reading the *Detroit News*, while the *Detroit Free Press* lay folded atop his briefcase.

This work was selected for inclusion in the International Contemporary Art Fair, Yokohama, Japan, 1992.

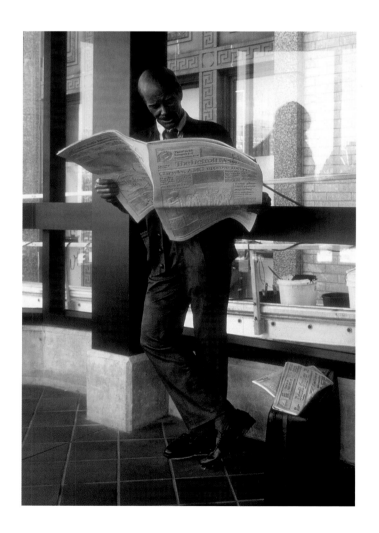

# People on the Move

"The Art in the Stations project is one of the most important public art projects in the entire country—both because of its size and the quality of its art. This tremendous achievement was conceived by one woman, Irene Walt, who formed a volunteer committee to select the artists and the works for the project. With support from the Mayor, the project was able to raise over $2 million. And one woman's dream became a reality for an entire city. There is no doubt that public art enriches and enhances our lives."

Sam Sachs II, then director of The Detroit Institute of Arts, in the introduction to the video, *Art in the Stations: Detroit People Mover*.

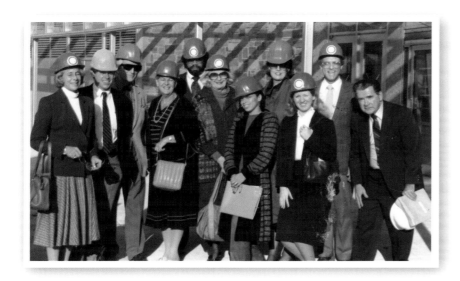

*In the fall of 1984, the new Detroit People Mover Art Commission visited Buffalo, New York, to see how that city was integrating public art into its transit system. From left: Lee Jaffe, Craig Carver, W. Hawkins Ferry, Irene Walt, Bill Taylor (of Nathan Johnson architectural firm), Jane Golanty, Shahida Mausi, Gail Camden, Cheryl Wragg (intern to the Art Commission), Andrew Camden, and an official of the Buffalo Transit System.*

*Gerome Kamrowski and Cosante Crovatto.*

Cosante Crovatto first met Irene Walt when he was in Detroit to oversee the installation of a Romare Bearden mural at The Detroit Institute of Arts.

Crovatto Mosaics has created numerous murals for installations throughout the United States at its artisans' studios in Spilimbergo, Italy. Among them are those at the Cobo Center and Joe Louis Arena stations of the Detroit People Mover.

The completed mosaics were shipped from Naples to New Jersey where Mr. Crovatto packed them into his station wagon and drove them to Detroit.

The artist selection process began in October 1984. Over 200 artists submitted slides for the Commission's consideration.

The work Gerome Kamrowski described in his handwritten and illustrated proposal was selected for the Joe Louis Arena Station. His murals were executed in mosaic—the photograph shows this work in process—by artisans in Spilimbergo, Italy.

Animal figures from the skies suggested by the constellation in the heavens. (ASTRONOMY)

Monoceros (the unicorn)
Canis Major (the greater dog)
Cancer (the crab)
Canis Minor (the lesser dog)
Aries (the ram)
Pisces Borealis (the northern fish
Pegasus (the flying horse)
Caput Medusae (Head of Medusa)
Hydra

SECTION

ACRYLIC CEMENT    METAL LATH
                          ACRYLIC
(REINFORCING RODS

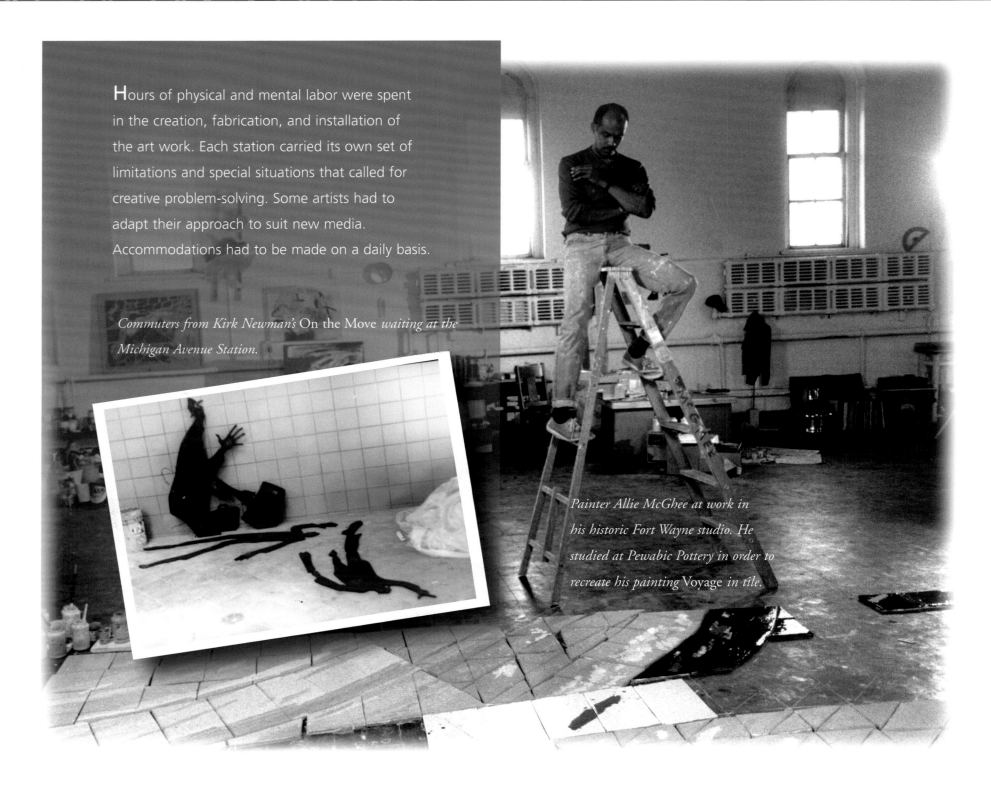

Hours of physical and mental labor were spent in the creation, fabrication, and installation of the art work. Each station carried its own set of limitations and special situations that called for creative problem-solving. Some artists had to adapt their approach to suit new media. Accommodations had to be made on a daily basis.

*Commuters from Kirk Newman's* On the Move *waiting at the Michigan Avenue Station.*

*Painter Allie McGhee at work in his historic Fort Wayne studio. He studied at Pewabic Pottery in order to recreate his painting* Voyage *in tile.*

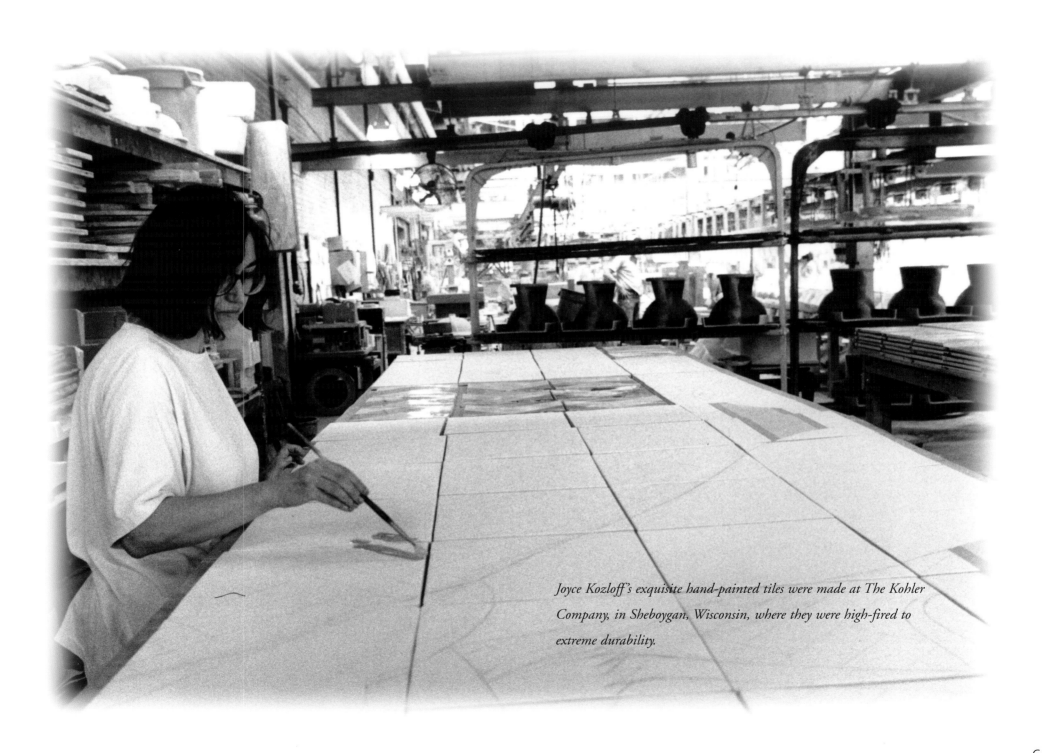

Joyce Kozloff's exquisite hand-painted tiles were made at The Kohler Company, in Sheboygan, Wisconsin, where they were high-fired to extreme durability.

*Several members of the Art in the Stations Commission visited Spilimbergo, Italy, to see the mosaics being assembled.*

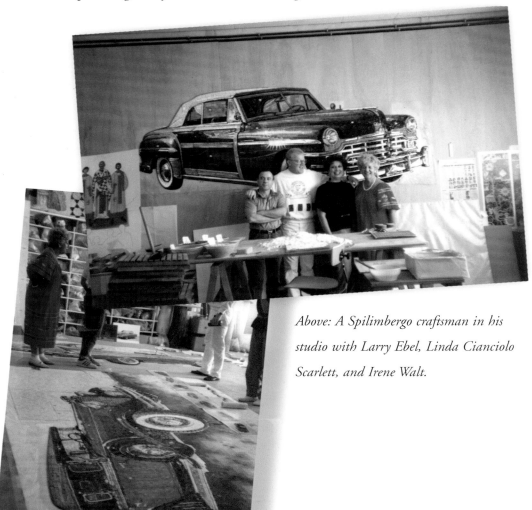

*Above: A Spilimbergo craftsman in his studio with Larry Ebel, Linda Cianciolo Scarlett, and Irene Walt.*

*Above: George Woodman with the newly-installed* Path Games *in April 2004. Jun Kaneko oversees installation of his untitled work in the Broadway station.*

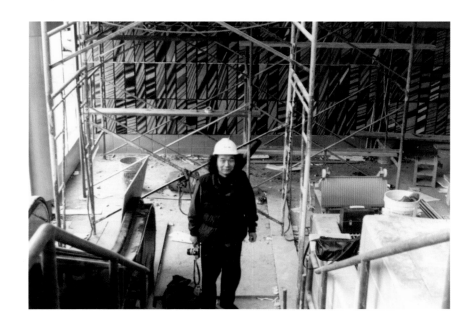

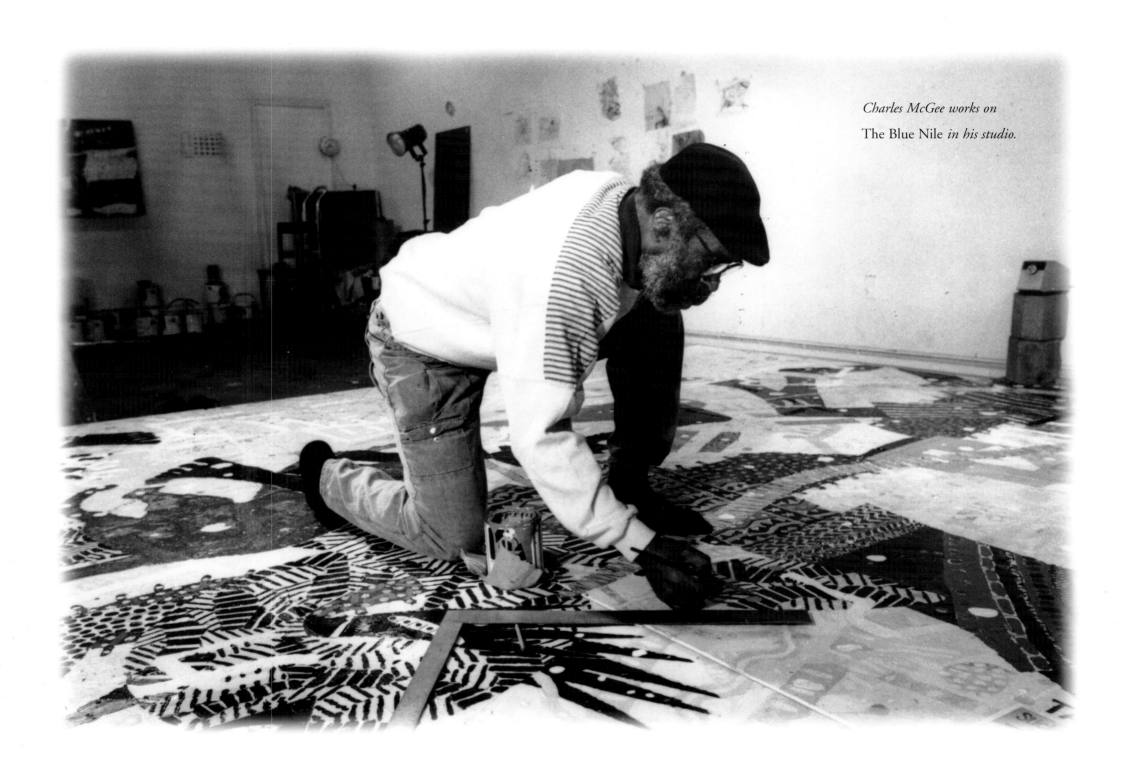

*Charles McGee works on*
The Blue Nile *in his studio.*

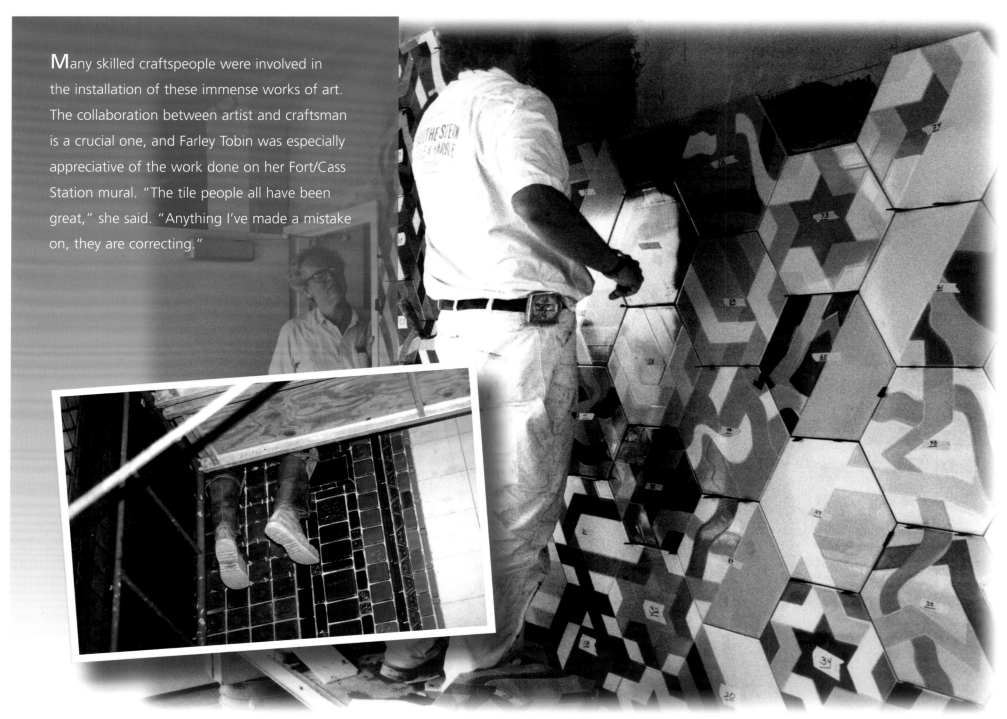

Many skilled craftspeople were involved in the installation of these immense works of art. The collaboration between artist and craftsman is a crucial one, and Farley Tobin was especially appreciative of the work done on her Fort/Cass Station mural. "The tile people all have been great," she said. "Anything I've made a mistake on, they are correcting."

*Installation of George Woodman's* Dreamers and Voyagers Come to Detroit.

*Al Loving "painting" the tiles of his* Detroit New Morning *before the tiles were fired at Pewabic Pottery.*

*Grace Serra, Director, Art Work Coordination, Art in the Stations; artist Al Loving, Jr.; Mary Jane Hock, then Director of Pewabic Pottery; and Irene Walt.*

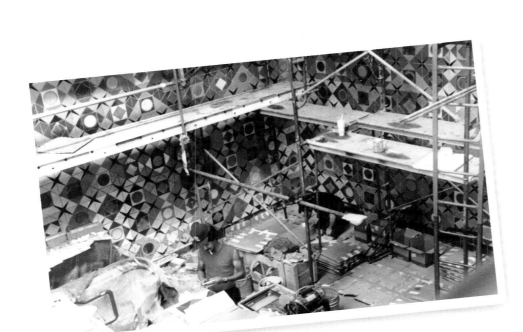

*Craftsmen setting the 13,844 tiles of Farley Tobin's Fort/Cass Station work.*

**C**oordinating the schedules of those involved in the multiple ongoing tasks of both construction projects—the construction of the People Mover itself and the installation of the Art in the Stations—required a highly developed sense of organization and diplomacy.

It took about two years for most works in Art in the Stations to progress from the maquette stage to installation.

Above: *Glen Michaels' maquette for* Beaubien Passage *at Bricktown Station*. Right: *Installation in process: Diana Pancioli/Pewabic Pottery's* In Honor of Mary Chase Stratton *at Cadillac Center Station*.

In 1992, three additional works of art were added to the Art in the Stations Collection: Anat Shiftan and Pewabic Pottery's commemorative mural in Times Square Station; Marshall Fredericks' *Siberian Ram* in the Renaissance Center Station; and Sandra Jo Osip's *Progressions II* in the Fort/Cass Station.

In 2002 to 2003, the Renaissance Center Station and its art was demolished during General Motors' remodeling of the complex. George Woodman was commissioned to create a new mural for the new station, which was installed in 2004.

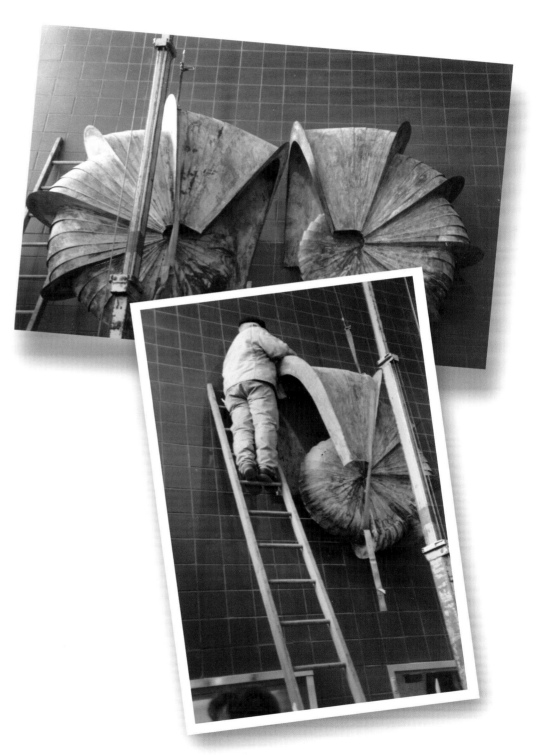

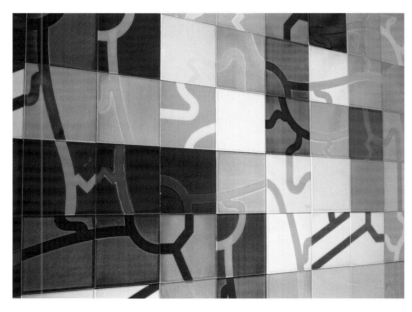

*George Woodman's* Path Games.

*Installation of Osip's* Progression II *at Fort/Cass Station.*

Academy Award-winners Sue Marx and Pamela Conn documented the Art in the Stations project in a 30-minute film—*Art in the Stations: Detroit People Mover.* For two years the filmmakers followed the progress of the art works from creation through installation, interviewing artists, craftspeople, Commission members—everyone involved in all aspects of the project.

The film premiered at The Detroit Institute of Arts on July 19, 1989.

Above: *Sam Sachs II, then director of The Detroit Institute of Arts, being filmed at Grand Circus Park Station for the* Art in the Stations *video.*

Right: *Sue and Hank Marx, with Monica and Balthazar Korab, at the documentary's debut.* [*Photo by Jeanne Whittaker/ The Detroit News*]

*Larry Ebel and Linda Cianciolo Scarlett with
Mayor Coleman Young at the November 14, 1988,
opening of the Cobo Center Station. [Photo by
Harold Robinson/The Detroit News]*

*Dorothy Brodie, Chairperson of the
Detroit Transportation Corporation,
the Honorable Damon J. Keith, and
Mayor Coleman Young.*

*Dr. and Mrs. Alexander Walt at
the opening night gala.*

The Detroit People Mover elevated transit system was
completed ahead of schedule and under budget in the
summer of 1987. On July 23, 1987, DPM and Art in the
Stations celebrated their opening night. What had begun
as one individual's idea a mere four years earlier was now
"one of the finest art projects in the country."

**Irene Walt** and her family moved to Detroit from South Africa in the early 1960s when her husband, Dr. Alexander Walt, was named Chief of Surgery at Detroit Receiving Hospital. Trained as a home economist, her career in public art began when Dr. Walt asked if she would help him find a way to make the hospital setting more pleasing. Through her work as its art advisor, Detroit Receiving Hospital now houses an acclaimed and world-renowned collection of over 900 works of art.

In her dedication to art *pro bono publico*, Irene Walt has volunteered her time and energy to many organizations and boards dedicated to improving the public spaces of Detroit. She founded the Friends of Detroit Receiving Hospital, and has served as chair of many art commissions, mostly recently that of the Alexander J. Walt Breast Cancer Center. She has lectured on public art in the U.S. and abroad.

Irene Walt has received numerous honors, including an Honorary Doctorate of Humane Letters from Wayne State University, the Michiganian of the Year Award, and the Civic Leader Award of the Governor's Awards for Art and Culture.

presented to
IRENE WALT
Chairperson, ARTS IN THE STATION
in recognition for the selection
of artistic ceramic tilework in
Detroit's People Mover stations
Southeastern Tile & Marble Company

**Balthazar Korab** was born in Budapest, Hungary, where he began his training as an architect. He continued his studies of art history at the Louvre and architecture at Ecole des Beaux Arts in Paris. He worked as an architect with the most renowned architects of the twentieth century, including Le Corbusier and Eero Saarinen. He received fourth prize in the Sydney Opera House Competition.

Balthazar Korab has been an independent photographer of architecture since 1958, and is world-famous for his work. He has published numerous books on architecture, and his photographs, which have been exhibited worldwide, can be found in many prestigious public and private collections.

*"I am an architect with a passion for nature's lessons and man's interventions. My images are born out of a deep emotional investment in their subject. Their content is never sacrificed for mere visual effects, nor is a polemic activism intended to prevail over an aesthetic balance."*

**STEPHEN ANTONAKOS (1926–  )**
**Greektown Station**
*Neon for the Greektown Station*
Stephen Antonakos was born in Agios Nikolaos, Greece, and lives in New York City. He developed his distinct style of sculpture, combining minimal steel forms with engaging color neon tubes, in the late 1960s. Mr. Antonakos has exhibited extensively, including the 1978 Sao Paulo International Biennial and the 1997 Venice Biennale. His work appears in many collections throughout the world, notably the Whitney Museum of American Art, the Los Angeles County Museum of Art, and the Museum of Modern Art of the City of Paris. He is the recipient of the Neuberger Museum of Arts lifetime achievement award.

**MARSHALL FREDERICKS (1907–1998)**
**Renaissance Center Station**
*Siberian Ram*
One of Michigan's most celebrated artists, Marshall Fredericks was born in Rock Island, Illinois, and graduated from the Cleveland Institute of Arts. He continued his studies in Stockholm, Sweden, with internationally acclaimed sculptor Carl Milles, who asked Mr. Fredericks to teach at Cranbrook Academy of Art in Bloomfield Hills, Michigan. Marshall Fredericks was the recipient of many public commissions throughout Michigan and the United States, including Detroit's "Spirit of Detroit," installed at the Coleman A Young City County Building.

**J. SEWARD JOHNSON, JR. (1930–  )**
**Grand Circus Park Station**
*Catching Up*
Seward Johnson trained as a painter but turned to sculpture in 1968. His figurative works are featured in more than 200 public and private collections, including Rockefeller Center; the Gettysburg Battlefield, Pennsylvania; and Queen Elizabeth Park, Vancouver, British Columbia. He has exhibited around the world—including the Galleria Ca D'Oro, Rome, Italy; the Venice Biennale; and the Jackson Art Museum at Yale University. Photographs and articles about his realistic artworks have appeared in *Art News*, *Art in America*, *Smithsonian Magazine*, *The New York Times*, and *The Washington Post*. Johnson's sculpture at the World Trade Center, *Double Check*, miraculously survived the destruction of September 11, 2001.

**GEROME KAMROWSKI (1914–2004)**
**Joe Louis Arena Station**
*Voyage*
Gerome Kamrowsk studied art at the Minnesota School of Art, the Art Students League in New York, and Chicago's New Bauhaus and Hans Hoffman School. In 1935, working in a Synthetic cubist style, he created his WPA murals for Northrup Auditorium at the University of Minnesota. During the 1930s and 1940s in New York, Mr. Kamrowski was at the forefront of the development of American Surrealism and Abstract Expressionism. His works from this period are in the collections of the Metropolitan Museum of Art, the Whitney Museum of American Art, the Guggenheim Museum, and the Museum of Modern Art. Mr. Kamrowski became head of the painting department at the University of Michigan in 1948.

**JUN KANEKO (1942–  )**
**Broadway Station**
*Untitled*
Jun Kaneko is one of the world's most renowned ceramic sculptors. Trained as a painter in his native Japan, Kaneko began exploring sculpture when he continued his art education in the United States at the University of California, under Peter Voulkos, and at Claremont Graduate School with Paul Soldner. He directed the clay program at Cranbrook Academy of Art, and served on the faculty of the Rhode Island School of Design. Jun Kaneko has exhibited widely and has been awarded numerous public commissions around the world. His work appears in many important public and private collections, including the American Crafts Museum, New York City; The Detroit Institute of Arts; Everson Museum, Syracuse, New York; the Smithsonian National Museum of American Art; Joslyn Art Museum, Omaha, Nebraska; Yamaguchi Museum, Japan; Arabia Museum, Helsinki; and European Ceramic Work Centre, Hertogenbosch, the Netherlands.

**JOYCE KOZLOFF (1942–  )**
**Financial District Station**
*"D" for Detroit*
Joyce Kozloff was born in Somerville, New Jersey. She received a B.F.A. from Carnegie Institute of Technology in Pittsburgh and an M.F.A. from Columbia University. She has taught at the Rhode Island School of Design, the Skowhegan School of Art in Maine, Rutgers, Cooper Union, and Washington University in St Louis, among others. A painter and ceramist, her works are in numerous collections, including the Museum of Modern Art; the Metropolitan Museum of Art; the Brooklyn Museum; the Albright-Knox Gallery, Buffalo; the Museum of Modern Art, Udine, Italy, the Neue Galerie, Aachen, Germany; and the Fogg Museum in Cambridge, Massachusetts. Her public art installations, many in transportation facilities, are in Massachusetts, Delaware, New York, California, Pennsylvania, Michigan, Washington, D.C., and Minnesota.

**ALVIN LOVING, JR. (1935–  )**
**Millender Center Station**
*Detroit New Morning*
Born into a distinguished Detroit family, Al Loving studied art at the Society of Arts and Craft in Detroit (now the College for Creative Studies). He received a B.F.A. from the University of Illinois and an M.F.A. from the University of Michigan. A year after moving to New York in 1968, Mr. Loving had his first one-person show at the Whitney Museum of American Art. A recipient of the prestigious Guggenheim Fellowship, he has created public commissions for Kennedy International Airport, the Veterans Administration Building in New York City, and the David Adamany Undergraduate Library at Wayne State University in Detroit. Mr. Loving's work is in many major collections, including the Metropolitan Museum of Art, the Whitney Museum of American Art, The Detroit Institute of Arts, and the Toledo Museum of Art.

**CHARLES McGEE (1924– )**
**Broadway Station**
*The Blue Nile*

Charles McGee studied art at the Society of Arts and Crafts in Detroit (now the College for Creative Studies). A driving force in Detroit's arts community, Mr. McGee headed the painting department at Eastern Michigan University; he founded the Charles McGee School of Art and the Contemporary Studio. His work has been exhibited at the Detroit Institute of Arts; the Dennos Museum in Traverse City, Michigan; Howard University in Washington, D.C.; and the Detroit Artists Market. McGee has created large-scale public commissions for The Detroit Institute of Arts; Bishop Airport in Flint, Michigan; Central Michigan University; Northern High School, Detroit; and the East Lansing, Michigan, City Hall.

**ALLIE McGHEE (1940– )**
**Michigan Avenue Station**
*Voyage*

Allie McGhee is one of Detroit's leading artists. He studied painting at Ferris State College and Eastern Michigan University. His public art works are included in the collection of Detroit Receiving Hospital; Toyoto City Hall, Toyota, Japan; Martin Luther King Center, Detroit; and Northern High School, Detroit, Michigan. His work is exhibited at the G. R. N'Namdi Gallery (Chicago and Detroit), The Detroit Institute of Arts, and Ohio State University.

**GLEN MICHAELS (1927– )**
**Bricktown Station**
*Beaubien Passage*

Glen Michaels, architectural sculptor, painter, and musician, has created many unique art commissions for major public buildings and private collections. His works appear in the World Bank in Washington, D.C.; Detroit Receiving Hospital; the Alexander J. Walt Comprehensive Breast Center of the Karmanos Cancer Institute in Detroit; William Beaumont Hospital in Royal Oak, Michigan; the University of Michigan; Oakland University in Auburn Hills, Michigan; the Macomb (MI) Center for the Performing Arts; and the Michigan State Library and Michigan Historical Center in East Lansing. Mr. Michaels received a degree in music from Yale University, a B.A. from the University of Washington, and an M.F.A. from Cranbrook Academy of Art.

**KIRK NEWMAN (1926– )**
**Michigan Avenue Station**
*On the Move*

Kirk Newman was born in Dallas, Texas. He received both his B.A. and M.A. from the University of Tulsa, and continued his studies at the University of Iowa and at the Ruskin School, Oxford University. An artist and an educator, Mr. Newman has worked extensively to broaden the scope of arts education. Primarily a sculptor, his work is displayed in numerous public and private collections, including Detroit Receiving Hospital, Kalamazoo Institute of Arts, Lear-Siegler Aircraft Company, Western Michigan University, the Michigan Bar Association, and the Conrad Hotel in Hong Kong.

**SANDRA OSIP (1948– )**
**Fort/Cass Station**
*Progression II*

Sandra Osip, a native Detroiter, lives and works in New York City. She studied sculpture at Wayne State University in Detroit, where she earned her B.S.; she received an M.F.A. from the Cranbrook Academy of Art. She has been a Fellow at the McDowell Colony in New Hampshire. Ms. Osip's work is in the collection at the Michigan Legacy Art Park, Harbor Springs, Michigan; The Detroit Institute of Arts; the Cranbrook Academy of Art; and the First National Bank of Chicago, among others.

**DIANA PANCIOLI (1942– )**
**Cadillac Center Station**
*In Honor of Mary Chase Stratton*

For most of the past 35 years, Diana Pancioli has worked in ceramics, making functional objects, public art in the form of tile murals, and sculpture. She holds a B.F.A. from Wayne State University and an M.F.A. from the New York State College of Art and Design at Alfred. Her professional career has ranged from operating a small production pottery in rural Canada, teaching in the Craft and Design Department of St. Clair College in Canada, and co-managing historic Pewabic Pottery's production department, to being a full-time professor of functional and sculptural ceramics at Eastern Michigan University. It was during her tenure at Pewabic Pottery that four People Mover murals were executed, including her *Homage to Mary Chase Stratton*. Ms. Pancioli is the author of *Extruded Ceramics: Techniques, Projects, Inspirations* (Lark Books, 2001).

**TOM PHARDEL (1950– )**
**Times Square Station**
*In Honor of W. Hawkins Ferry*

Tom Phardel is chair of the Ceramics Department at the College for Creative Studies in Detroit, Michigan. He has also taught at Eastern Michigan University, the University of Michigan, and Pewabic Pottery. The recipient of numerous awards, including a Michigan Council for the Arts Cultural Affairs Grant, Mr. Phardel's austerely elegant steel and ceramic sculptures are in the collection of the Everson Museum, Syracuse, New York: the Detroit Institute of Arts; Henry Ford Community College; the Dennos Museum, Traverse City, Michigan; and many private collections.

**ANAT SHIFTAN (1955– )**
**Times Square Station**
*Untitled*

Anat Shiftan, was born in Israel, and holds graduate degrees from both Eastern Michigan University and the Cranbrook Academy of Art, where she studied under Jun Kaneko. Ms. Shiftan has headed both the production/design and education departments of Pewabic Pottery in Detroit. She has taught at the Bezalel Academy of Art and Design in Jerusalen; the College for Creative Studies in Detroit; and the University of Michigan in Ann Arbor. A recipient of several Michigan Council for the Arts grants, her work has been exhibited in the United States and in Israel.

**FARLEY TOBIN (1952– )**
**Fort/Cass Station**
*Untitled*

Farley Tobin, a native New Yorker, trained at the New York College of Art and Design at Alfred, where she received her B.F.A., and at the Cranbrook Academy of Art, where she received an M.F.A. She furthered her studies at Columbia University and the Camberwell School of Art and Crafts in London. Tobin has created site-specific tile works for Rice University, the Connecticut Fire Academy (for which she received the prestigious Terrazzo Award), the University City Science Center in Philadelphia, and the United States Courthouse and Federal Building in San Jose, California, plus numerous private installations. She has taught at the Rhode Island School of Design and at the Haystack Mountain School, where she also served on the board of directors. A recipient of a National Endowment for the Arts Craftsman Grant, among others, Ms. Tobin's tile works have been featured in many national publications and museum exhibitions, including Architectural Art at the American Craft Museum in New York City.

**GEORGE WOODMAN (1932– )**
**Renaissance Center Station**
*Path Games*

George Woodman, painter, tile maker, and photographer, lives in New York City and Florence, Italy. He received a degree in philosophy from Harvard University and a Masters of Fine Art from the University of New Mexico. Mr. Woodman taught art theory and painting at the University of Colorado until 1995. His work has been featured in exhibitions at the Rochester Institute of Technology, the New York State College of Ceramics, and Wright State University. A recipient of a National Endowment for the Arts Award, he has a public installation in the Delavan/College Station, Niagara Falls Transit Authority, in addition to those in Art in the Stations.

# Contributors to Art in the Stations
# of the Detroit People Mover (1984–1992)

*The authors of this book are deeply indebted to the following persons and organizations that were involved in the original Art in the Stations Project that was in effect from 1984 to 1992. Neither the art in the stations nor this book would have been possible without their generous support.*

## Commission Members

Irene Walt, Chairperson
Andrew L. Camden
Gayle S. Camden
Craig Carver †, Michigan Council for the Arts
W. Hawkins Ferry †
Jane G. Golanty
Grovenor Grimes †
Lee Jaffe †
The Honorable Damon J. Keith
Joyce LaBan
David Baker Lewis
Shahida A. Mausi, Detroit Council of the Arts
Mary Lou Wood

Grace Serra, Executive Director, Art Commission

Dorothy Brodie, Chairperson, Detroit Transportation
    Corporation (1985–1993)

Coleman A. Young, Mayor of Detroit (1973–1993) †

† = deceased

## Contributors

Chrysler Motor Fund
City of Detroit
Commuity Foundation of Southeastern Michigan
Detroit Council for the Arts
Detroit Edison
Detroit People Mover Art Commission
Federal Mogul
W. Hawkins Ferry
First Federal of Michigan
Walter and Josephine Ford Foundation
Ford Motor Fund
Forest City Enterprises/Millender Center Associates
Gannett Foundation and the *Detroit News*/Gannett Outdoor
General Motors Foundation
Philip Graham Fund (WDIV and *Newsweek*)
Hudson Webber Foundation
Hudson's
Knight Foundation—*Detroit Free Press*
Kohler Art Center
Kresge Foundation
Linda Kughn
Richard Kughn, Carrail
MichCon Corporation
Michigan Bell, an Ameritech Corporation
Michigan Council for the Arts
Michigan Department of Transportation
National Endowment for the Arts
Alan E. Schwartz
Sibley's Shoes, Inc.
Skillman Foundation
Stroh Foundation
A. Alfred Taubman
Turner Construction Company
U.S. Urban Mass Transit Administration

## Contractors

Urban Transportation Development Corporation, Ltd.
Turner Construction
    *James Mitnick*
    *John Breed*
Gannett Fleming Co.
    *Robert Holler*
Walbridge Aldinger
    *John Rakolta, Jr.*

## Installers and Fabricators

Crovatto Mosaics
    *Cosante Crovatto*
Empire Tile Co.
    *Ray Bianchini*
Southeastern Tile and Marble Co.
    *Dave Harvey*
    *Al Harvey*
Ribaudo Tile and Marble Co.
Art-Glo (Columbus, Ohio)
C & H Erectors
    *John Fraser*
Gary Steffy Lighting Design
    *Gary Steffy*
Planet Neon
    *Patrick Foley*

## Logo

Larry Ebel and Linda Cianciolo Scarlett

## Contributors to the Inaugural Grand Tour

Abam Engineers
Alexander & Alexander
Gannett Fleming
Fluor Transportation and Infrastructure, Inc.
Greater Detroit Building and Construction Trades Council
Kolon, Bittker & Desmond, Inc.
Lea and Elliott
Lewis, White and Clay
Lutron, Inc.
Millender Center
Miller-SAB Electrical Contractors
Soils and Materials Engineers
Turner Construction
UTDC Corporation
Walbridge Aldinger

## Brochure

Smith, Hinchman & Grylls (now The SmithGroup)
    *Ralph Youngren*

## Video Production and Direction

    *Sue Marx and Pamela Conn*

## Photography

Balthazar Korab Ltd.
    *Balthazar Korab*
    *Monica Korab*